The Innocents

Photographs and Interviews by Taryn Simon
Commentary by Peter Neufeld and Barry Scheck of the Innocence Project

Umbrage Editions

The Innocents

The Innocents

An Umbrage Editions Book

Publisher: Nan Richardson
Managing Editor: Lesley Martin

Photographer's Credits:
Producer and Project Editor: Althea Wasow
Production Manager: Sarah Baden
Photographer's Assistants: Louis Gabriel and Kevin Hooeyman
Case Profiles: Huy Dao, The Innocence Project

Art Direction: Joseph Logan for Baron & Baron

A Guggenheim Fellowship in Photography from The John Simon Guggenheim
Foundation is gratefully acknowledged for enabling this production.

Taryn Simon's royalties will be donated to the Innocence Project.

This project would not be possible without the ongoing support and valuable
commitment from ADORAMA and COLOR EDGE.

An exhibition organized by P.S.1 Contemporary Art Center, a MoMA affiliate,
New York, will accompany this publication.

Photographer's Foreword

"I was asked to come down and look at the photo array of different men. I picked Ron's photo because in my mind it most closely resembled the man who attacked me. But really what happened was that, because I had made a composite sketch, he actually most closely resembled my sketch as opposed to the actual attacker. By the time we went to do a physical lineup, they asked if I could physically identify the person. I picked out Ronald because, subconsciously, in my mind, he resembled the photo, which resembled the composite, which resembled the attacker. All the images became enmeshed to one image that became Ron, and Ron became my attacker."

–Jennifer Thompson, on the process to identify the man who raped her.

During the summer of 2000, I worked for *The New York Times Magazine* photographing men who were wrongfully convicted, imprisoned, and subsequently freed from death row. After this assignment, I began to investigate photography's role in the criminal justice system. I traveled across the United States photographing and interviewing men and women convicted of crimes they did not commit. In these cases, photography offered the criminal justice system a tool that transformed innocent citizens into criminals, assisted officers in obtaining erroneous eyewitness identifications, and aided prosecutors in securing convictions. The criminal justice system had failed to recognize the limitations of relying on photographic images.

For the men and women in this book, the primary cause of wrongful conviction was mistaken identification. A victim or eyewitness identifies a suspected perpetrator through law enforcement's use of photographs and lineups. These identifications rely on the assumption of precise visual memory. But through exposure to composite sketches, mugshots, Polaroids, and lineups, eyewitness memory can change. Police officers and prosecutors influence memory—both unintentionally and intentionally—through the ways in which they conduct the identification process. They can shape, and even generate, what comes to be known as eyewitness testimony.

Jennifer Thompson's account of the process by which she misidentified her attacker illustrates the malleability of memory. A domino effect ensues in which victims do remember a face, but not necessarily the face they saw during the commission of the crime. "All the images became enmeshed to one image that became Ron, and Ron became my attacker."

In the case of Marvin Anderson, convicted of rape, forcible sodomy, abduction, and robbery, the victim was shown a photographic array of six similar black-and-white mugshots and one color photo. The face that stood out to the victim was the color photo of Anderson. After the victim picked Anderson from the photo array, she identified him in a live lineup. Of the seven men in the photo array, Anderson was the only one who was also in the lineup. Marvin Anderson served fifteen years of a 210-year sentence.

In the case of Troy Webb, convicted of rape, kidnapping, and robbery, the victim was shown a photo array. She tentatively identified Webb's photo, but said that he looked too old. The police then presented another photo of Webb taken four years before the crime occurred. He was positively identified. Troy Webb served seven years of a forty-seven-year sentence.

The high stakes of the criminal justice system underscore the importance of a photographic image's history and context. The photographs in this book rely upon supporting materials—captions, case profiles and interviews—in an effort to construct a more adequate account of these cases. This project stresses the cost of ignoring the limitations of photography and minimizing the context in which photographic images are presented. Nowhere are the material effects of ignoring a photograph's context as profound as in the misidentification that leads to the imprisonment or execution of an innocent person.

I photographed each innocent person at a site that came to assume particular significance following his wrongful conviction: the scene of misidentification, the scene of arrest, the alibi location, or the scene of the crime. In the history of these legal cases, these locations have been assigned contradictory meanings. The scene of arrest marks the starting point of a reality that is based in fiction. The scene of the crime, for the wrongfully convicted, is at once arbitrary and crucial; a place that changed their lives forever, but to which they had never been. Photographing the wrongfully convicted in these environments brings to the surface the attenuated relationship between truth and fiction, and efficiency and injustice.

The wrongfully convicted in this book were exonerated through the use of DNA evidence. Only in recent years have eyewitness identification and testimony been forced to meet the test of DNA corroboration. Eyewitness testimony is no longer the most powerful and persuasive form of evidence presented to juries. Because of its accuracy, DNA allows a level of assurance that other forms of evidence do not offer. In the exoneration process, DNA evidence pressures the justice system and the public to concede that a convicted person is indeed innocent. In our reliance upon these new technologies, we marginalize the majority of the wrongfully convicted, for whom there is no DNA evidence, or those for whom the cost of DNA testing is prohibitive. Even in cases in which it was collected, DNA evidence must be handled and stored and is therefore prey to human error and corruption. Evidence does not exist in a closed system. Like photography, it cannot exist apart from its context, or outside of the modes by which it circulates.

Photography's ability to blur truth and fiction is one of its most compelling qualities. But when misused as part of a prosecutor's arsenal, this ambiguity can have severe, even lethal consequences. Photographs in the criminal justice system, and elsewhere, can turn fiction into fact. As I got to know the men and women in this book, I saw that photography's ambiguity, beautiful in one context, can be devastating in another.

–Taryn Simon

Commentary

The innocents whose stories follow served collectively, and, depending on how you can best imagine the unimaginable, either 558.5 years, or 203,853 days, or 293,548,320 minutes in American prisons for crimes they did not commit. Some were sentenced to death. Without warning or just cause, all were one day swept off the streets, forcibly separated from their families and friends, and ultimately bound over into a maddening nightmare.

Post-conviction DNA tests performed on critical pieces of biological evidence proved they were innocent simply, elegantly, and definitively. But resurrecting their lives, and those of their loved ones, all shattered by unthinkable injustice, is a complex and messy process. Yet it must be undertaken at once, as a matter of common decency, as a signal we can face the truth, as a measure to redeem our aspiration that America should be, can be, fair and just.

These fifty individuals represent a cross-section of a uniquely instructive group. Most had no criminal record. Their backgrounds reflect the diversity of our nation. Wrongful conviction can happen to anyone: a science teacher arrested at his mother's home in Kansas four years after a rape murder in Oklahoma and sent away for life based on jailhouse snitch testimony; a grave digger from West Virginia put away by phony forensic tests from the state's crime lab director; a rich man's son convicted in his hometown of Tulsa of child rape despite the testimony of seventeen alibi witnesses that he was in Dallas the day of the crime; a marine corporal from Orange County, California convicted of assaulting his wife until it was discovered seventeen years later she was attacked by a serial killer named the "bedroom basher"; a black volunteer fireman holding two jobs in Hanover, Virginia and living with a white woman convicted by an all-white jury based on testimony that the perpetrator bragged about having a white girlfriend; a former altar boy managing a Pizza Hut in Austin, Texas, threatened with execution and shown pictures of the death chamber in Huntsville by his interrogators, confesses to a murder in exchange for a life sentence; an Air Force veteran known to frequent a bar in Phoenix who wound up on death row based on the false claim his teeth matched a bite mark on a dead bartender's neck. Yes, it can really happen to anyone, and it does, but it is still more likely to happen to someone who is poor, black, brown, or mentally disabled.

There have been, as these lines are being written, 124 post-conviction DNA exonerations in the United States and another eight in Canada. We have been privileged to know most of the exonerated, including all twelve who barely escaped execution. When we founded the Innocence Project ten years ago, our goal was straightforward: to walk as many innocent people out of prison or off death row as possible. The demand for our services has grown exponentially. Our staff and two-dozen law students are handling over 200 active cases on behalf of convicted persons seeking DNA testing. We have over 1,500 letters from inmates seeking representation which have not yet been reviewed, and approximately 4,000 more pending requests which are under active consideration.

To our great disappointment, in half of the cases the Project eventually screens and accepts, we still have to litigate against prosecutors unwilling to consent to post-conviction DNA testing. Only about half the states in our country have passed statutes assuring that the wrongfully convicted can get a chance to prove their innocence with a DNA test. Congress has not yet passed the Innocence Protection Act, federal legislation that would guarantee post-conviction DNA testing in all the states. And in 75 percent of our cases, where a DNA test could definitively determine guilt or innocence, the evidence is reported lost or destroyed. We are in a race against time.

Yet, a movement that began slowly a decade ago has grown dramatically as more "innocence projects" are formed at law and journalism schools across the country—projects that take on the harder cases of the wrongly convicted where there is no DNA evidence. A courageous governor in Illinois, George Ryan—spurred by death row exonerations—declared a moratorium on executions, commuted 174 death sentences to life, and issued a comprehensive report filled with worthwhile reforms. Now, stories of liberation from wrongful convictions fill the nation's papers almost weekly. But for all of these innocents the exhilaration and relief felt during those first days of freedom is always tempered by a profoundly personal understanding of the larger problem, and an aching resolve to, somehow, help fix a broken system. No one else should have to endure this.

Not so long ago, claiming an innocent person was imprisoned was audacious, risky, and close to unprovable in the eyes of a skeptical judiciary—science changed that. But DNA testing alone is not a panacea for what ails the criminal justice system. It is estimated that only 20 percent of serious felony cases involve biological evidence where DNA tests can confirm or exclude a suspect as the perpetrator. What about all the rest? How can we identify and remedy the causes of wrongful convictions so that the innocent will not forever rot in our prisons or await execution? How can we seize the opportunity—this learning moment—created by DNA exonerations?

The answers lie in the cases of the innocents themselves. From a post-mortem examination of these miscarriages of justice, patterns emerge and unprecedented insights are provided into the systemic failures of criminal justice. These cases are a Rosetta stone to unraveling the causes of wrongful convictions and finding remedies to prevent them. There has never been a database like it in the history of our jurisprudence, more than a hundred cases in which no one can credibly dispute that our system produced grievous and fatal errors. Together, they present a meticulously documented compendium of ills that compel meaningful reform: mistaken eyewitnesses, coerced or fabricated confessions, junk or fraudulent forensic science, defense lawyers who are indifferent, under funded or literally asleep, prosecutors who hide exculpatory evidence, jailhouse snitches who tell lies, dishonest cops and the insidious corruption of racial bias that poisons the system in myriad ways.

Already we know there are some practical and effective solutions to correct, or at least minimize these problems. Scientists, researchers, and lawyers, armed with the irrefutable truth of these compelling narratives from the innocents, are, for the first time, convincing police commissioners, district attorneys, judges, state legislators, and other policy makers to implement new techniques for eyewitness identification, to require video recording of all suspect interrogations, to impose quality assurance and controls for crime labs and technicians, and to enforce performance standards and provide adequate compensation for indigent representation. The improvement of law enforcement not only protects the innocent, it helps apprehend the guilty. Real progress can be made. All this pain is for a purpose.

As much as these remarkable photographs of the innocents and their families bear witness to the forces that led to this immense suffering, so, too, do they oblige us to ponder their survival. Why didn't they just give up, go crazy, or kill themselves? How do they overcome anger, despair, and bitterness? What explains their capacity to walk out of the most violent prisons with dignity and grace, express forgiveness for their mistaken accusers, and articulate hope for the system that nearly destroyed them? Yet, such displays of courage should not distract attention from the true dimensions of their plight. They all suffer terribly upon release. Employers won't hire them. People still suspect they're guilty or at least tainted by their imprisonment. We have yet to know one whose sleep was not plagued by persistent nightmares. Few are justly compensated. Most receive nothing. None of the innocents ever achieve "closure" or "get over it." Their only hope is to learn to live with it. What you do see here are survivors, amazing spirits capable of compassion and sacrifice. In spite of everything, they did not simply endure; they prevailed.

–Peter Neufeld and Barry Scheck

FREDERICK DAYE

Alibi location, American Legion Post 310, San Diego, California
Where 13 witnesses placed Daye at the time of the crime
Served 10 years of a life sentence

In 1984, a young woman in San Diego, California was forced into her car, raped by two men, and then robbed. The victim made a cross-racial identification of Frederick Daye as the first assailant, who pushed her into the car and opened the door for the other perpetrator. Daye had been pulled over by a policeman for a minor violation, at which time a Polaroid was taken of Daye. The Polaroid was added to the photo array used to identify the perpetrator. The other defendant, who was tried in separate proceedings, declined to testify at Daye's 1984 trial. The police refused to investigate a suspect named Smallwood who was known to associate with the other defendant. The prosecution presented serology results on a semen stain and false statements that Daye made to police at the time of arrest. Daye raised a mistaken identification defense but an all-white jury convicted him of two counts of rape, kidnapping, and vehicle theft. In 1990, the other defendant revealed that Daye had played no part in the crime. Daye eventually received new counsel, who was able to stop the destruction of, and win access to, the biological evidence. Ten years after Daye's conviction, DNA testing corroborated the other defendant's statements, established Daye's innocence, and identified Smallwood as the real perpetrator. The prosecutor was unable to try Smallwood because the victim refused to press charges. She claimed that the police had permanently altered her memory, convincing her that Daye had committed the crime.

"If none of this had happened to me, I'd probably be on Def Comedy Jam because I'm probably one of the funniest people in the United States—and that's a God-given talent. God blessed me to be funny. I can make anybody laugh at any given situation. If I can make a prison full of 6,000 people with life sentences in Folsom Prison laugh, I'll have a club full of half-drunk motherfuckers pissing on themselves. But I ain't been able to do none of that because I haven't had no closure in my life. I got to get this shit out of the way.... If I sat down with a person and emptied my heart out and let them know everything I went through, he'd be stark raving mad. He wouldn't know how to deal with it. And it's something that I have to live with on a day-to-day basis. This shit's in my head all the time. I can't black this out. I don't care how much beer I drink. It might go away for a moment, but in the middle of the night I'm gonna wake up shivering and sweating knowing that I had to go through this. I wouldn't wish this on nobody, nobody." *—Frederick Daye*

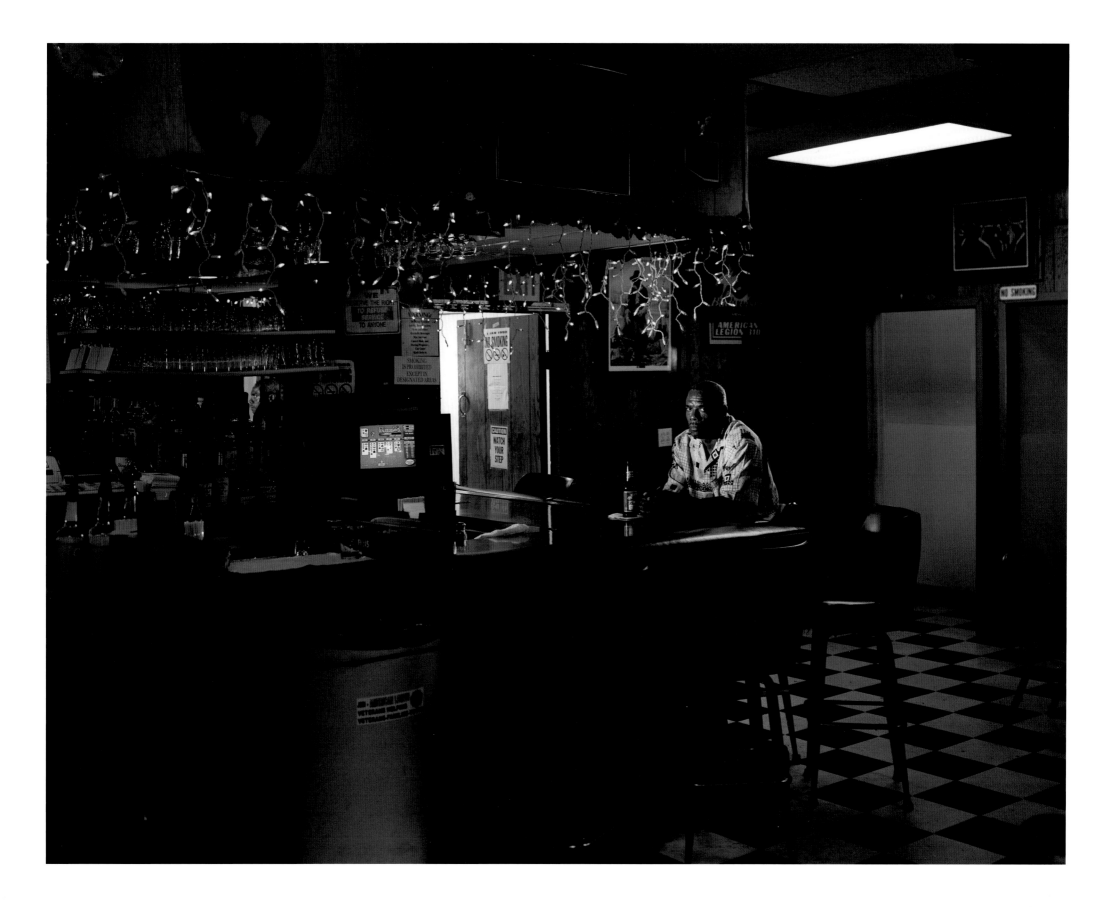

TROY WEBB
Scene of the crime, The Pines, Virginia Beach, Virginia
Served 7 years of a 47-year sentence

In January 1988, a young woman in the Virginia Beach area was attacked as she stepped
out of her car. The assailant robbed her at gunpoint, forced her to strip, and raped her.
The victim's cross-racial identification of Troy Webb from two photographic arrays led to his
conviction of rape, kidnapping, and robbery in 1989. In her initial identification, the victim
picked Webb's photograph but said that he looked too old. In the second array, the police
used a picture of Webb taken four years earlier, securing her identification. Testing on semen
recovered from the rape kit was inconclusive. At trial and after conviction, Webb maintained
his innocence, and he finally gained access to the biological evidence in 1996. DNA test
results proved that he was not the perpetrator. He was released from prison the same year,
and was eventually pardoned by the governor of Virginia on the grounds of innocence.

"She said the guy was light-skinned, 5'6 to 5'7, weighing 130–150 lbs., medium build.
I was the only one in the lineup that was light skinned. Everyone was two- to three-tones
darker than me. If you'd seen the lineup you'd laugh. It was funny. I'm the only one who fit
the description she gave, as far as being light-skinned. That made me stand out. Of course
she's gonna pick my picture. It was a set up from the beginning.... When I looked at my
pre-sentence report, I got to the very last page: it said whoever raped the girl gave her
gonorrhea. They knew this from the day I got arrested. They never told me this. I found
that out after I was found guilty. It was already ninety days and you only have thirty days
to enter new evidence. So I couldn't even use it. It was right in front of my face and I
couldn't even use it. I got really angry then." *–Troy Webb*

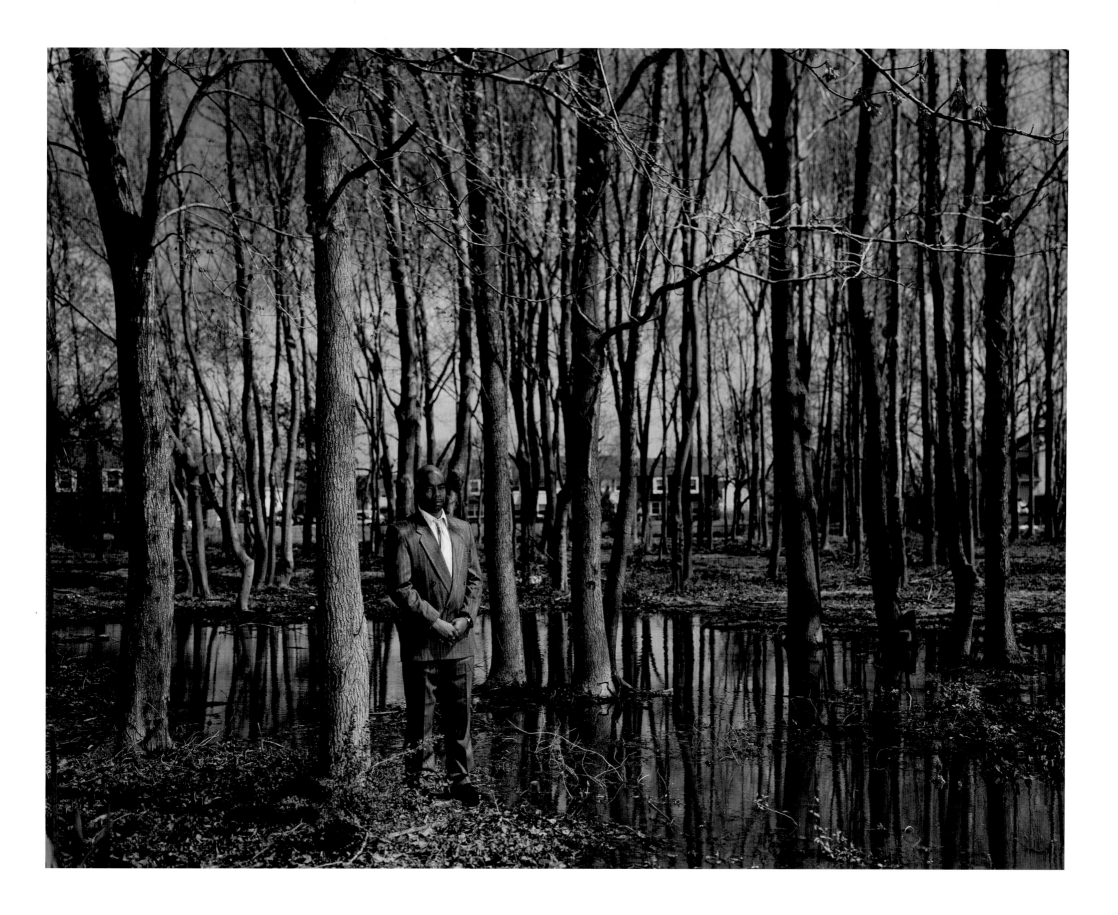

CHARLES IRVIN FAIN
Scene of the crime, the Snake River, Melba, Idaho
Served 18 years of a death sentence

In 1982, a young girl was abducted while walking to school in Nampa, Idaho. Her body was found days later in a ditch near the Snake River. Police focused their investigation on Charles Fain, who was new to the area. Many men, including Fain, were asked to provide hair samples to be tested against hairs found on the victim. Based on hair comparisons performed by the FBI, Fain was convicted of kidnapping, rape, and murder, and sentenced to death in 1983. Prosecutors also relied on testimony from two jailhouse snitches who claimed that Fain had confessed and provided detailed information about the crime. Fain maintained his innocence, claiming that he was at his father's house in Oregon on the day of the crime. Eighteen years later, Fain secured access to the evidence, and the hairs were subjected to mitochondrial DNA testing. He was excluded as the contributor of the hairs, and the court ordered his release in August 2001. Fain became the eleventh person freed from death row due to postconviction DNA testing.

"They took me back to a room. Lieutenant Patrick was there and he had a death warrant. He read it, cracked a few jokes, and that was about it.... They had to give us a copy of the procedure. We read it to see how it went. They strap you on the gurney. The spiritual advisor leaves. Then they put the needles in and walk behind this thing and start pushing some buttons. Wouldn't take more than about four minutes." *–Charles Irvin Fain*

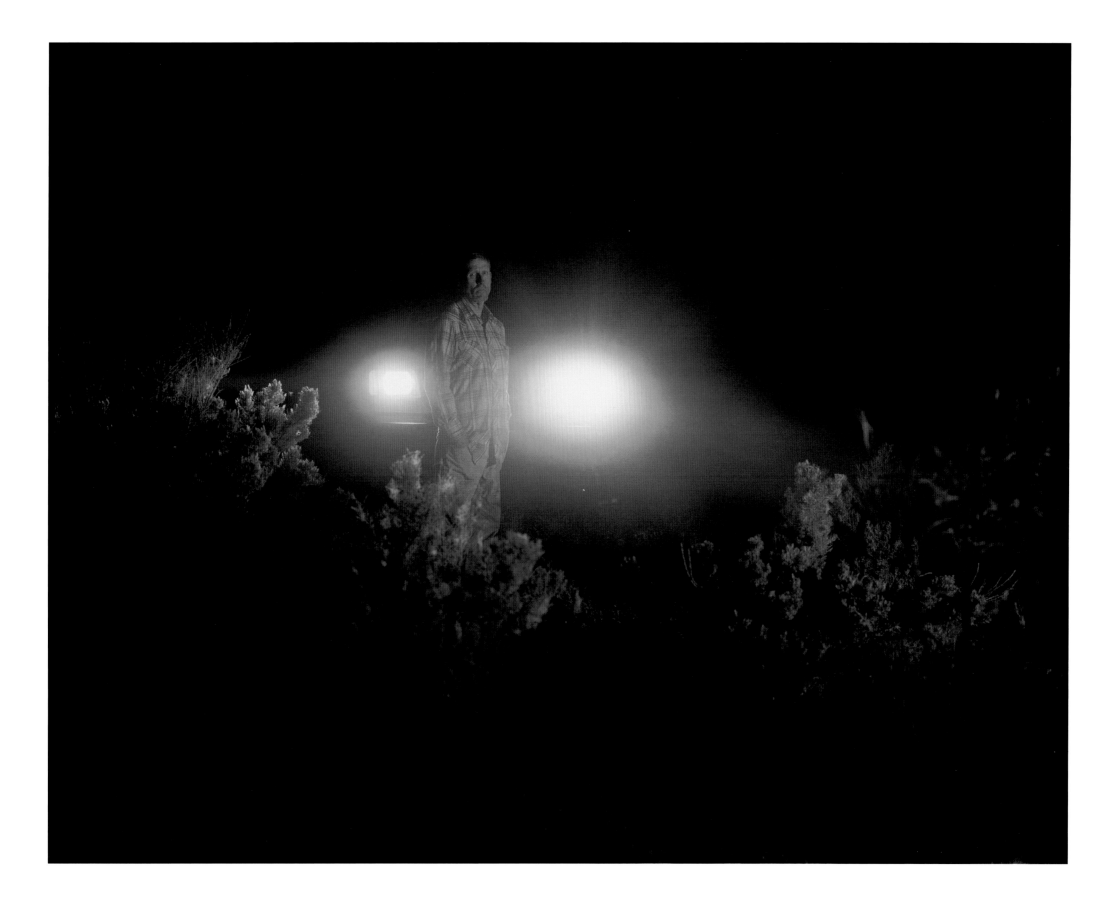

HECTOR GONZALEZ
At home, Brooklyn, New York
The week of his homecoming
Served 6.5 years of a 15-to-life sentence

In 1995, a fight that started inside a Brooklyn nightclub spilled into the street, where members of the Latin Kings gang stomped and stabbed a man to death. Hector Gonzalez, who was not a Latin King, was a witness at the scene. His cousin, who was involved in the fight inside the club, bled on Gonzalez. Later that evening, when looking for his cousin at a hospital, Gonzalez was arrested and identified by an eyewitness as one of the assailants. His bloody clothes were taken and subjected to conventional serology testing. Gonzalez and three co-defendants were all convicted of murder. Years later, during a federal investigation of the Latin Kings conducted by the U.S. Attorney's office in the Eastern District of New York, participants in the murder revealed that Gonzalez was innocent. DNA testing was then conducted on the clothes, demonstrating that the blood was his cousin's and not the victim's. Based on the new evidence, the Brooklyn District Attorney joined in a motion to exonerate Gonzalez, who was released in April 2002.

"Freedom, finally. That's what I felt. Finally, finally, finally. I'm home, where I was supposed to be, where I belong. Home. That's how I felt. Like, wow! I felt like I could kiss the floor, but the floor's too dirty I guess. I felt relief. I felt like all that stress and all that weight that I had on me was finally gone. I felt good…. My mother didn't know until that same day that I was coming home. She just got a call, like, 'Yo, go to court, he's coming home.' So she rushed." *—Hector Gonzalez*

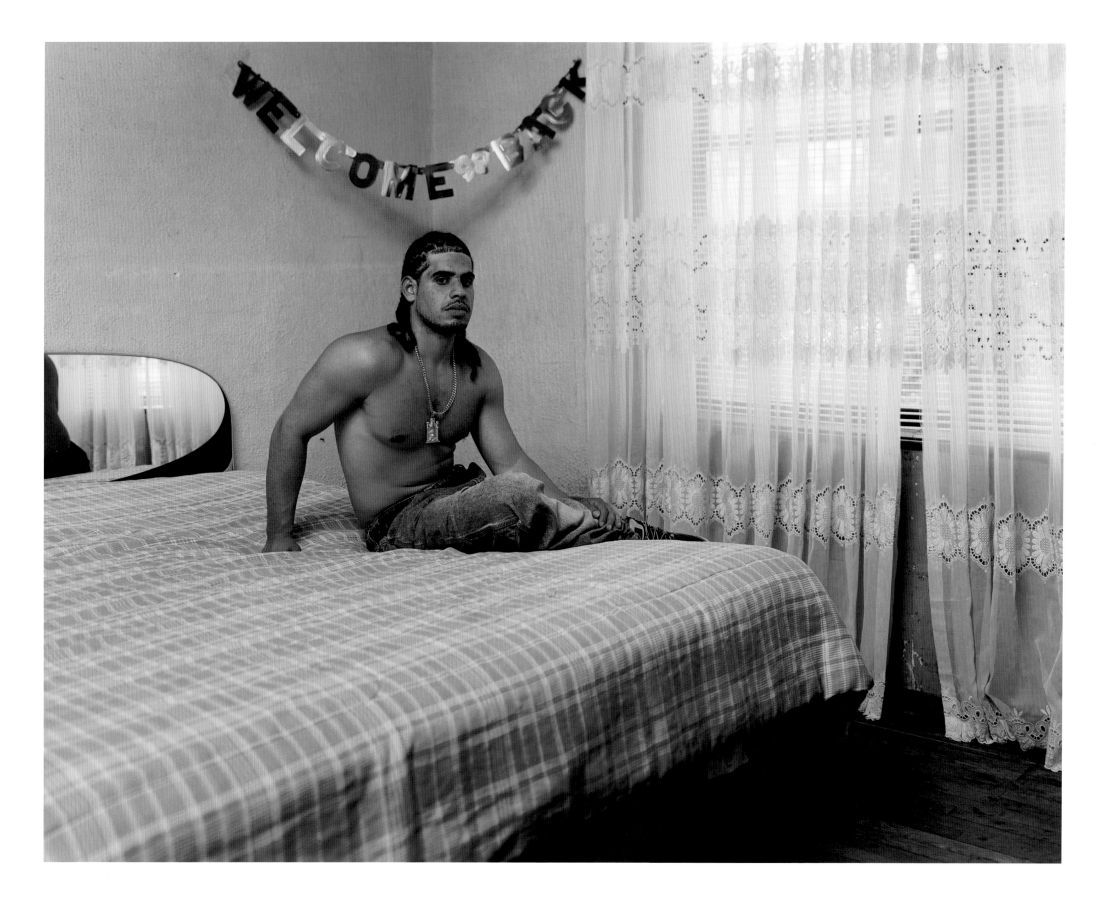

EARL WASHINGTON
Mt. Trashmore, Virginia Beach, Virginia
With wife, Pam
Served 17 years of a death sentence

In 1982, a young mother in Culpeper, Virginia, was raped and repeatedly stabbed on her marital bed. She attempted to get help before she collapsed outside her front door. Before she died, she told police that a lone black man was responsible. A year later, Earl Washington was arrested after a drunken assault on his neighbor. During police questioning about various unsolved crimes, Washington confessed to four different crimes, including the Culpeper rape and murder. Three of the four confessions were dismissed due to inconsistencies in the descriptions and to the victim's testimony that he was not the perpetrator. However, there was no victim to clear him in the Culpeper murder. His confession was deemed reliable, even though he did not know the victim's race, whether or not she was alone, where she lived, her physical attributes and age, or how many times he had supposedly stabbed her. His trial lawyer also failed to notice or at least appreciate a crime scene report that stated that the semen stains on the blanket recovered from the bed where she was raped and stabbed had a genetic type different from both Washington and the victim's husband. Despite psychological analyses reporting that Washington had an IQ of 69, and that he would defer to any authority figure in the confession process, he was convicted and sentenced to death. In August 1985, a month before his execution date, volunteer lawyers from New York reexamined his case and managed to secure a stay just nine days before he was scheduled to die. Although DNA tests conducted on sperm in 1993 excluded Washington, he was time barred from introducing new evidence. (Virginia law at the time gave defendants only twenty-one days after conviction to introduce new evidence. The results did secure a commutation of his death sentence to life without parole.) Six years later, the governor reluctantly consented to more sophisticated DNA testing, which not only dispositively excluded Washington but matched another man imprisoned for a similar crime. Based on these results, Washington was granted an absolute pardon for the murder and rape charges and was released on parole in February 2001.

"I used to hate myself for what happened to me. It took me some time to get over. I used to tell my momma, 'I just didn't like myself no more for being locked up.' I hate myself for going to prison knowing I was an innocent man. At one time I thought it was my fault for agreeing with what the cops said…. What happens to you when you die? Some people say you go to hell, some people say you go to heaven where God is at. The basic question is where would I have went? Me? I would have went to heaven. I always believe that when people die they go to heaven. What is hell? To me, hell is being in the world. The way I look at it, prison is hell. To me, heaven is a beautiful place where people live forever." *–Earl Washington*

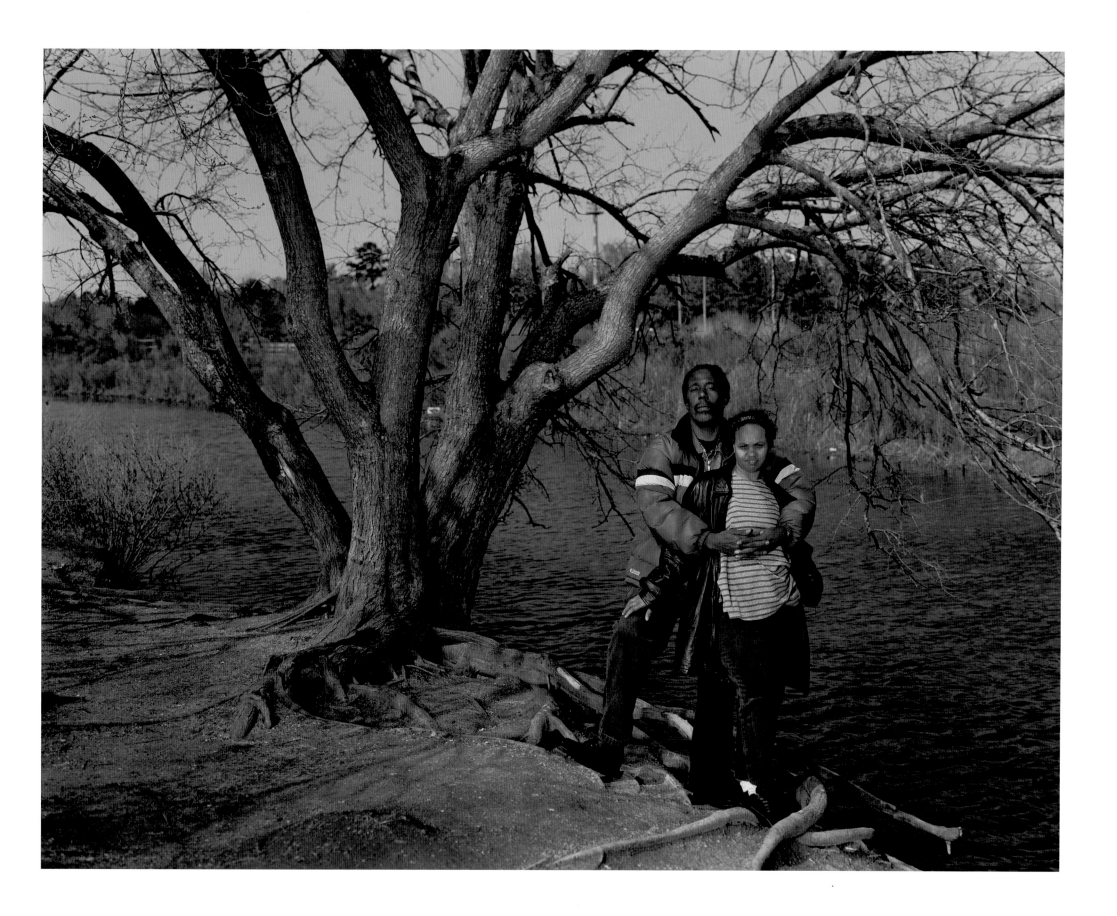

A.B. BUTLER
At work, hauling dirt, Tyler, Texas
Served 16.5 years of a 99-year sentence

In May 1983, a young woman in Tyler, Texas, was abducted from a parking lot, driven to a rural area, and raped twice. The victim later identified A.B. Butler from a photographic lineup, a live lineup, and then in court. Butler gave an alibi—he was at a club with friends—that witnesses corroborated. Nevertheless, he was convicted later that year of aggravated kidnapping, with rape as the aggravating factor. Butler continued to push for testing of the biological evidence in order to prove his innocence, but his appeals were denied. Sixteen years later, Butler finally secured access to the evidence for DNA testing. The first round of testing did not yield conclusive results, but subsequent testing on swabs from the rape kit excluded Butler as a possible contributor. The final round of testing confirmed that Butler was not the source of semen found on the victim's shirt. Based on these results, A.B. Butler was freed from prison in January 2000 and was officially pardoned in May 2000.

"When they arrested me and read my *Miranda* rights, I requested an attorney. The detective walked in the room I was waiting at, and asked me, 'What did I want with an attorney?'… I didn't say anything. He said, 'You must be guilty.' That sprung me right there. I got aggravated. I said, 'I'm not guilty.' He said, 'Why you need a lawyer? It might be two or three days before a lawyer can come here. You say you haven't done this. There's no way she can pick you out. If you go ahead and get through with this you'll be out of here.' With that trickery I signed the waiver of attorney. I had a job interview and other business that needed to be taken care of that day. It was a lot of pressure on me to sign that waiver. When I got into the lineup I was picked out by the victim." *–A.B. Butler*

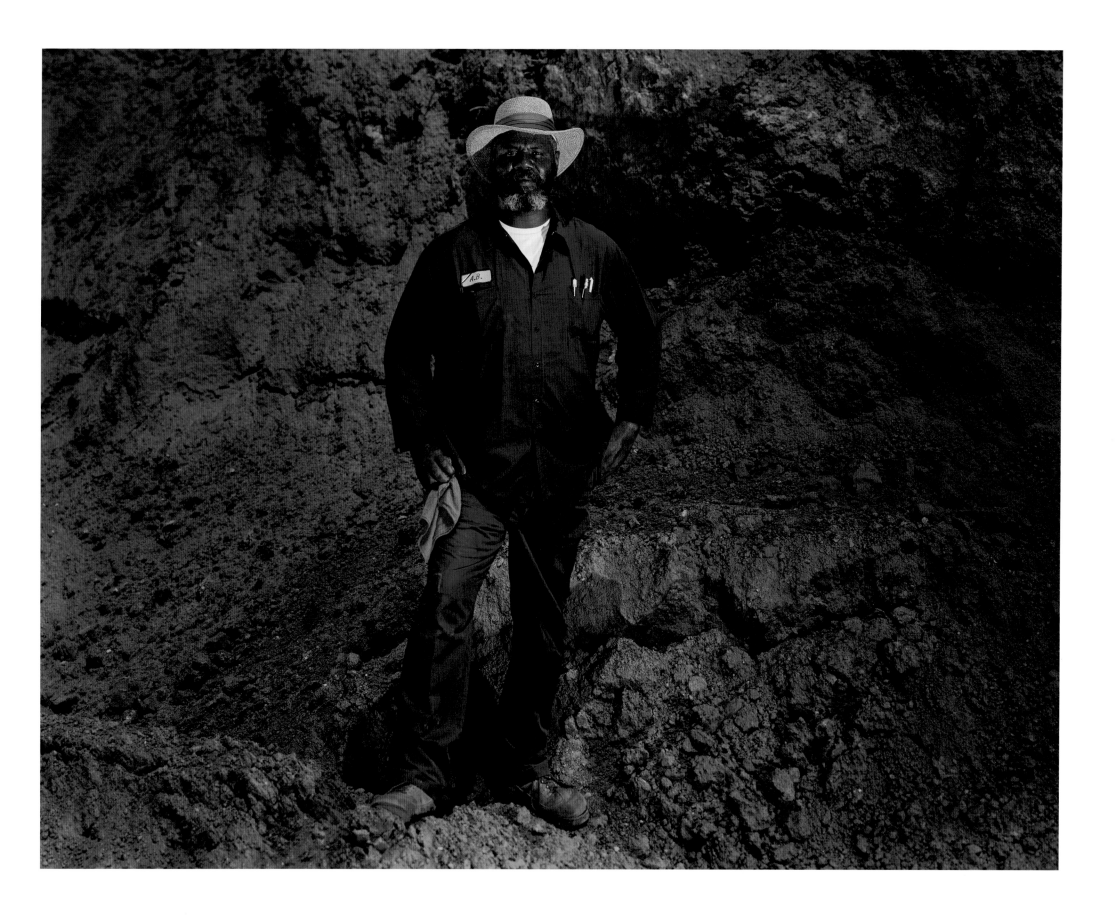

KEVIN BYRD

Scene of identification and arrest, Hometown Foods, Houston, Texas
Served 12 years of a life sentence

In January 1985, a pregnant woman was raped at knifepoint in her Houston-area home while her two-year-old daughter lay asleep beside her. The victim described her attacker as a white male with an unusual brown shade to his skin. Months later, she saw Kevin Byrd, a black man whose complexion is dark, in a grocery store and identified him as her assailant. Despite major differences between his appearance and the victim's initial description, Byrd was convicted that year and sentenced to life in prison. Serological testing on the semen evidence could not exclude Byrd. His appeals were denied, and the evidence in the case was scheduled for destruction in 1994. Instead, the evidence was accidentally marked for preservation. In 1997, that evidence was subjected to DNA testing, which excluded Byrd as the perpetrator. The judge, district attorney, and sheriff wrote a letter to then-Governor George W. Bush requesting a pardon for Byrd on the grounds of innocence. In October 1997, four months later and only after a court hearing to validate the results, Bush signed Byrd's pardon.

"Two police cars pulled up. A girl was in the back seat. She was shaking her head, saying, 'That's the man, that's the man.' I didn't know what was going on. It was a nightmare to me. The officers put handcuffs on me and threw me into the back of the car. They didn't read me my rights. They didn't tell me what I was being charged with until we reached the sex crime division. They said I was being charged for rape. Come to find out the girl originally said the man that assaulted her was a clean-shaven white male. He was not black. I mean that's kind of strange the way the justice system just accepted that and didn't look into it thoroughly. It still remains a mystery. They were just trying to close the books on this case." *–Kevin Byrd*

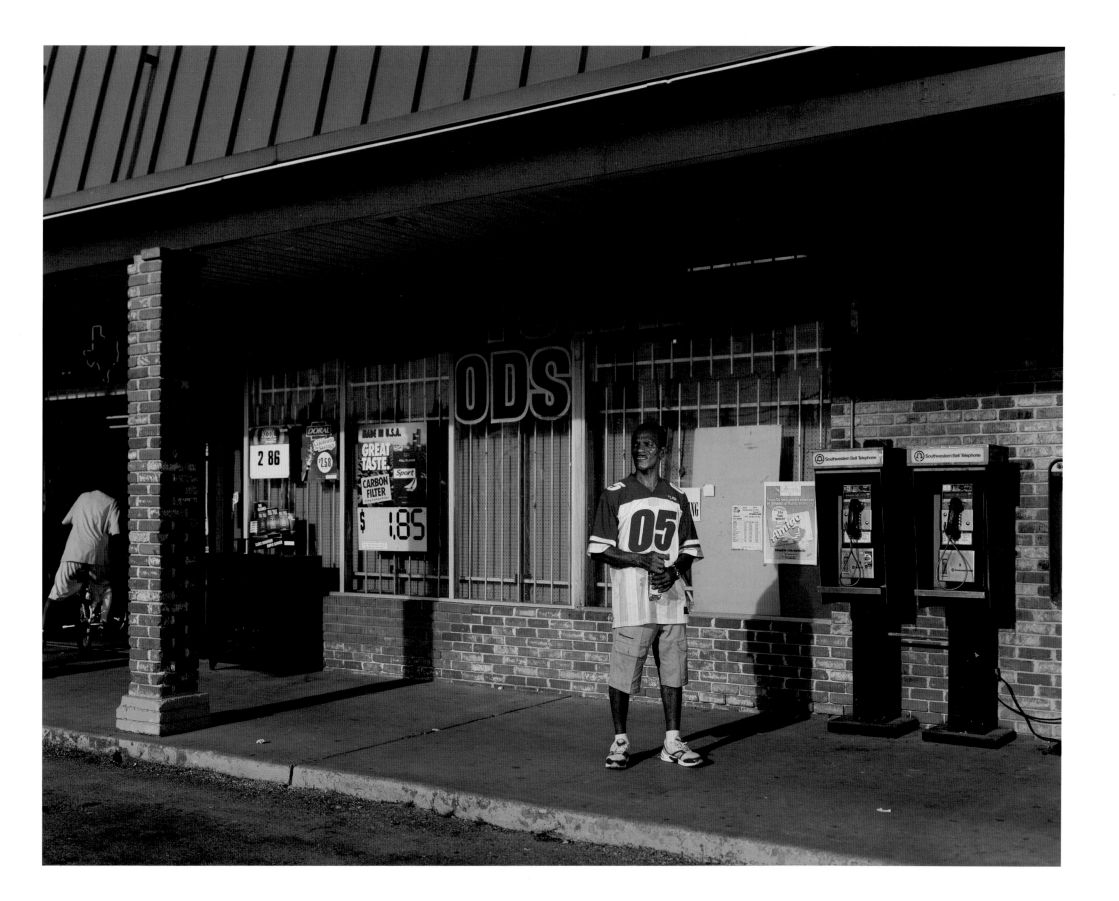

NEIL MILLER
Scene of arrest, Fenway Park, Boston, Massachusetts
Served 10 years of a 26-to-45-year sentence

In 1989, a man forced his way into the apartment of a college student. She was raped and robbed on her roommate's bed. The rape squad detective collected the roommate's sheets with fresh semen stains. Initially, the victim was unable to make an identification. Weeks later, after a composite sketch was prepared, another officer told the detective that the sketch resembled Neil Miller. An old photo of Miller was included in a photo array and shown to the victim. She selected Miller's picture. After he was arrested, the Boston police lab conducted conventional serology tests on the sheet and vaginal swabs from the rape kit. Although the test on the vaginal swab was inconclusive, the bloodtype on the semen stain lifted from the sheet excluded Miller. However, the prosecutor argued at trial that the semen stain on the sheet was not left by the rapist but from a boyfriend of the roommate. Neither the boyfriend nor the roommate was ever produced at trial. Miller was convicted of all charges in December 1990. Ten years later, Miller secured DNA testing on the sheet and vaginal swab. The semen stain on the sheet and vaginal swab revealed identical DNA profiles that excluded Miller. The story about the roommate and her boyfriend was false. Miller was exonerated and released in 2000.

"Life is better in prison. Because I wouldn't have the worries that I have now. Sad to say, but it's true. There are days that I sometimes feel, I really wish, that I was still in jail. Because then I wouldn't have half the problems that I have now. Shoot. It's good to have freedom, but it's just too much freedom. I'm not used to this much freedom. I was so used to being confined. Life is a little better in there because I would have a job. Any prison that I went into, there was always a place where I can get a job. It's not like that now, out here. Out here, you got to have a query done on you. Out here, you gotta know people. Out here, you gotta explain why you haven't worked in the past ten years. Out here, you gotta explain why you checked off that you would like to explain your reasoning for being incarcerated and all that. In there? I didn't have to do that. In there, all I had to do was say, 'Sergeant, I heard you're the one who handles the kitchen jobs—I'd like to put my name down on the list for the kitchen jobs. My name is Neil Miller.'" –*Neil Miller*

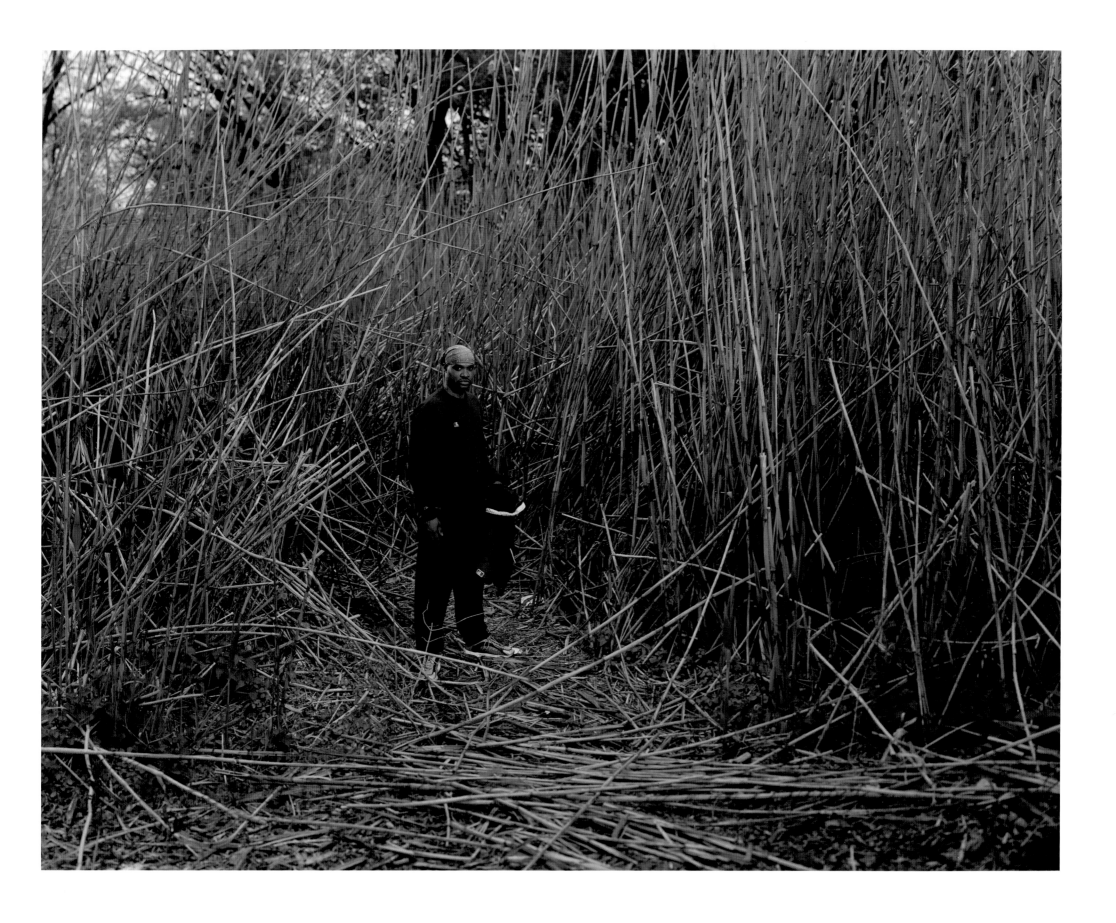

RAY KRONE
Nick Meyer's backyard, Glendale, Arizona
In the sandrail Ray built, kept while he was in prison by his friend Nick
Served 10 years of a death sentence

In December 1991, the naked body of a woman was found in the men's room of a
Phoenix, Arizona, bar. The victim, one of the bar's employees, had been stabbed to death.
No fingerprints were found, and the saliva from bite marks on her body revealed that the
assailant had the most common blood type. Ray Krone, a regular customer, became the
target of the investigation after police learned from a friend of the victim that Krone was
set to help close the bar on the night of the murder. Police asked Krone to bite a Styrofoam
cup, and later claimed that the bite marks matched those found on the victim's breast and
neck. Krone presented an alibi defense, claiming to be at home asleep during the time of
the attack, but was convicted of murder and kidnapping in 1992 and sentenced to death.
Four years later, he won an appeal but was convicted again, largely due to expert testimony
matching the impression of his teeth to the bite marks on the victim. He was sentenced to
life, although the judge expressed doubts about Krone's guilt. In 2002, DNA testing on the
saliva and blood from the scene excluded Krone as a contributor and inculpated another
man, Kevin Phillips, who was incarcerated on rape charges. In April 2002, Krone was
released, and the indictment against him was formally dismissed later that month. Phillips
has been charged with murder and sexual assault. Since the reinstitution of capital
punishment in 1976, Ray Krone is the one-hundreth death row inmate to be freed as
a result of new evidence of innocence.

"I never liked what they done to me. I never liked the power, the control they exercised on
me. I was not a problem. I never was a problem. I wasn't someone who needed to be in
prison, handcuffed, shackled, strip-searched, bent over, and everything else that they do in
prison. I was not a person who needed to be controlled like that. And I don't need to have
them controlling me now." *–Ray Krone*

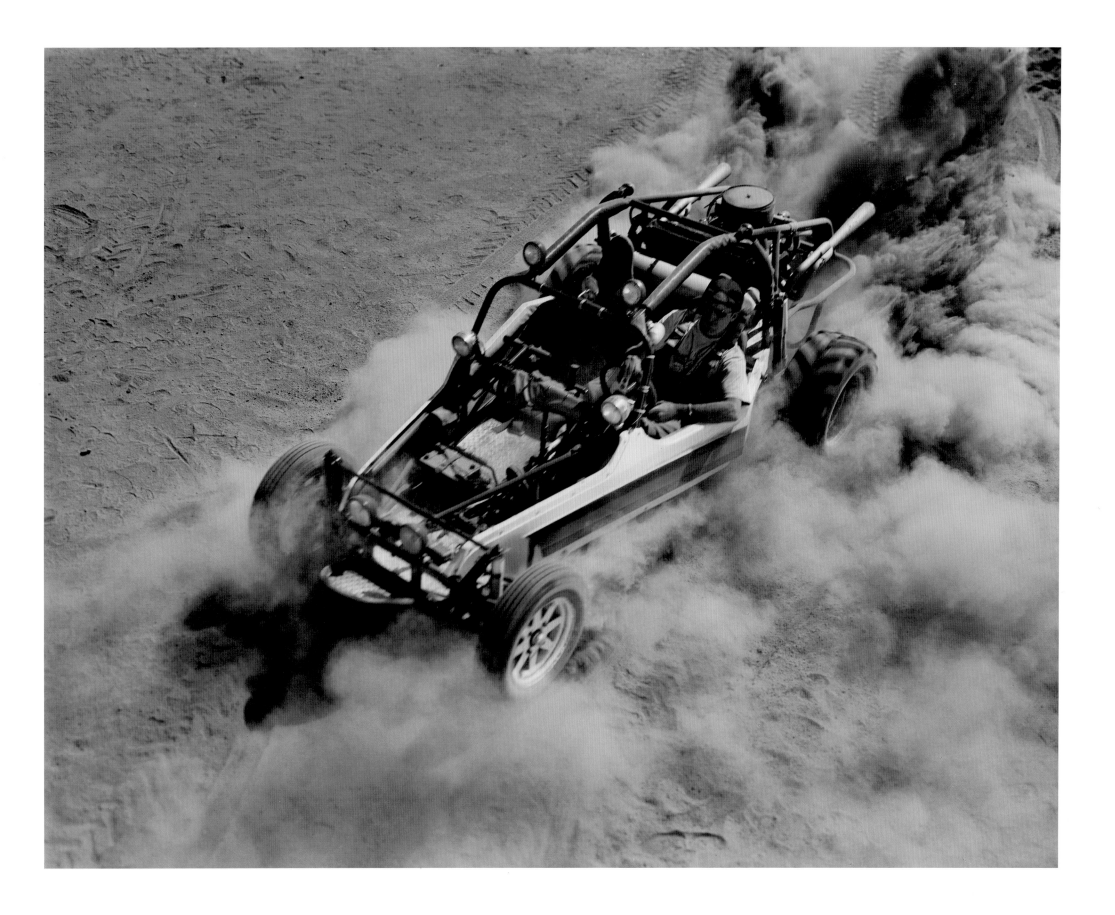

ANTHONY ROBINSON
Scene of the crime, University of Houston, Texas
Served 10 years of a 27-year sentence

In 1986, a young woman at the University of Houston was raped. She described her assailant as a black man with a mustache wearing a plaid shirt. Based on this description, police stopped Anthony Robinson as he was picking up a car for a friend from a university parking lot. Though he was wearing a plaid shirt, Robinson did not have a mustache and was clean-shaven. Still, minutes later, the victim identified him as the assailant in a one-on-one showup procedure. The prosecution relied mainly on the victim's cross-racial identification, and Robinson was convicted of sexual assault in 1987. Robinson pressed for forensic testing to prove his innocence, even offering to give police blood samples. He was paroled in 1997 and continued his efforts to prove his innocence. Once he had raised enough money, he sought DNA testing on the biological evidence collected from the victim. Test results proved that he could not have been the perpetrator. After the prosecution's tests confirmed the exculpatory results, Robinson's record was cleared. He was issued a pardon in 2000.

"Since the incident occurred, I've taken on the affectation of making sure I'm presentable when I go somewhere. It's kind of stifling for me 'cause I'm really a casual guy. But if you don't dress up in such a manner as to say, 'Okay, I'm a normal person,' the opportunity is there for them to say whatever they want: 'He fits the description.' Very rarely is somebody going to say: 'He was wearing a shirt, a tie, a pair of slacks, and some hard-soled shoes.' That's not the description that they're going to use to grab you…. I keep records and tabs on where I was, what I was doing, and how long I was there. It's a small price to pay for my freedom. I keep general notations, little scraps of papers. If I go to the store, I'll keep a receipt or I'll make notations on my calendar. I just recently stopped keeping a logbook— so that's an improvement. My fear is if I stop, it might happen again…. Don't take this the wrong way, but it's kind of hard for a black man to live in Texas and not believe in God. That's the only way you can make rational sense of the irrational things that are happening around you." *–Anthony Robinson*

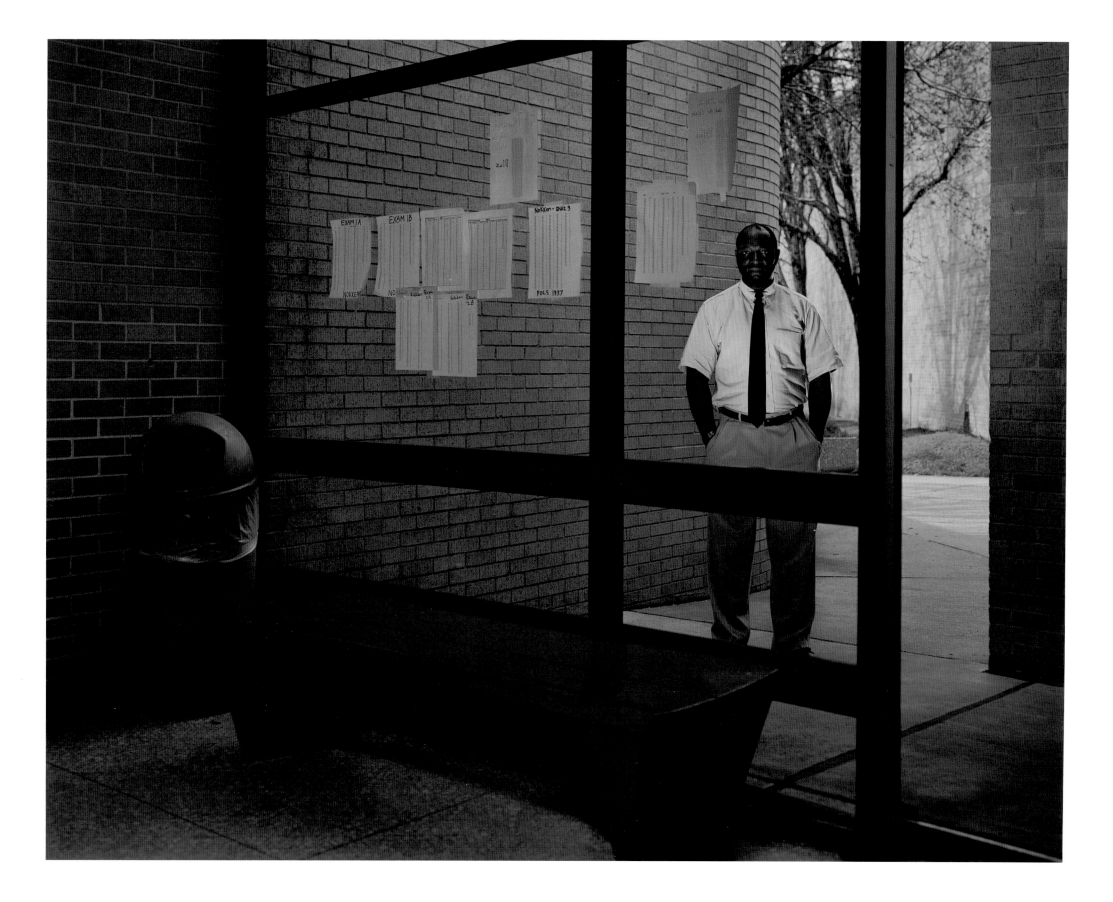

WILLIAM GREGORY

Wick's Parlor, Louisville, Kentucky
With fiancée Vicki Kidwell, whom he dated prior to conviction
Gregory was pool champion in prison
Served 7 years of a 70-year sentence

In 1992, two women who lived in the same apartment complex in Louisville, Kentucky, were attacked in their homes. The first victim, twenty years old at the time, was awakened by a naked black man, who used the victim's panty hose to cover his head. The panty hose were removed in the struggle, and the perpetrator fled. The victim picked someone other than William Gregory from a photo lineup, describing an assailant ten years younger, heavier, and without facial hair. However, after seeing Gregory, a Sears electronics salesman, in the same apartment complex (the only black resident), she later identified him as her assailant. The police inspected Gregory's body for scratches and searched his apartment, but they found no evidence. The second victim, over seventy years old at the time, was assaulted while Gregory was out on bond. Although she also did not pick out Gregory in a photo lineup, she identified him in a one-on-one showup procedure conducted weeks after the crime. Gregory maintained his innocence and provided alibis for both crimes, but was convicted of rape, attempted rape, and two counts of burglary in 1993. After his appeals failed, Gregory sought DNA testing on the hairs left behind in the panty hose. These hairs were determined to be African-American hairs, and were tied to him at trial. As the victim claimed to have had no black visitors in her home, these hairs were presented as necessarily the assailant's. Mitochondrial DNA testing proved that they were not from William Gregory. Gregory was released in 2000, becoming the first person in Kentucky to be exonerated due to postconviction DNA testing.

"The jury's prejudices were in the closet, but the door was cracked. You could tell the door was cracked by the expressions on their faces when my white fiancée said my nails was beautiful and I was handsome. The jury was like, 'What is wrong with her?' They cracked the door so to speak. You could see the prejudice on their faces. The spotters in my case looked at the jury, came back and said, 'He's convicted.' They said that because of what they saw when my fiancée got on the witness stand—she was a very classy white woman, well kept, came from a rich family. They convicted me with their prejudices, their biases. They basically got rid of their pencils and stopped taking notes." *–William Gregory*

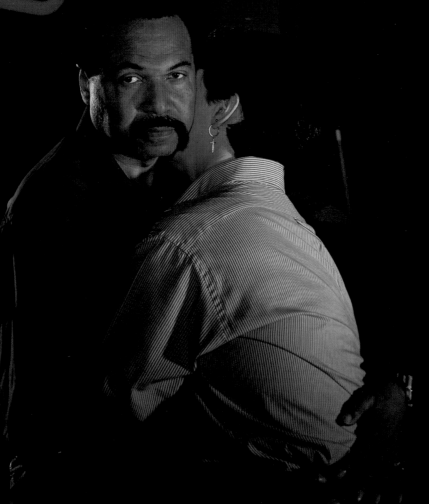

TIM DURHAM

Skeet shooting, Tulsa, Oklahoma
11 alibi witnesses placed Durham at a skeet-shooting competition at the time of the crime
Served 3.5 years of a 3,220-year sentence

In May 1991, an eleven-year-old girl in a wealthy Tulsa, Oklahoma neighborhood was about to go swimming in her backyard. A man, who said he was there to do yard work, raped her. Based primarily on her description of the assailant—a short man with red hair—and her tentative identification of a photograph, Tim Durham was arrested. At trial, the prosecution presented the testimony of two scientific experts. The hair expert testified to finding pubic hairs of an unusual hue that appeared to be cut with a razor and associated them with Durham. The DNA expert testified to finding a faint result in the third round of testing of semen found on the girl's swimsuit. Durham was included in this result, along with ten percent of the population. Durham presented an alibi defense, showing that he was in Dallas, Texas on the day of the crime, helping his father participate in a skeet-shooting contest. Eleven witnesses unequivocally testified to his presence at the event, many of them church elders. Nonetheless, Tim Durham was convicted of several charges of rape and robbery in 1993 and sentenced to 3,220 years in prison. On appeal, the sentence was cut by 100 years. After his conviction, Durham began seeking newly developed forms of DNA testing to prove his innocence. In 1996, new DNA test results revealed that semen found on the victim's swimsuit could not have come from Durham. Based on this new evidence, his conviction was vacated and his case dismissed in 1997. After his trial, Durham learned that another young girl had been raped by a short man with red hair in the same Tulsa neighborhood. She was shown Durham's photo, but did not pick it. Just before these crimes were committed in 1991, a man on parole for sexually assaulting children had moved to the area. That man, Jess Garrison, hung himself after Tim Durham's arrest. Garrison was also short, with red hair.

"I have considered the possibility that somebody might accuse me of a similar crime or another type of crime that I did not commit. When I was released from prison I had considered developing a device that could be worn just like a pager that could be used to track my movements. I know that the technology is available today in a small form, where we can track vehicles, particularly if they are stolen. There are agencies out there who use global positioning satellites to track the whereabouts of the cars so that the police can make a recovery. I considered trying to develop a small pager-size device that could be worn by anyone to track their whereabouts. It could track them down to as small an area as ten meters to show that the person that was accused, if they had one of these devices, could be pinpointed pretty much exactly where they were at the time that crime was committed and prove that they did not commit that crime. That would allow the police and the investigators time to move on and further their investigation so they could find the real perpetrator of a crime." *–Tim Durham*

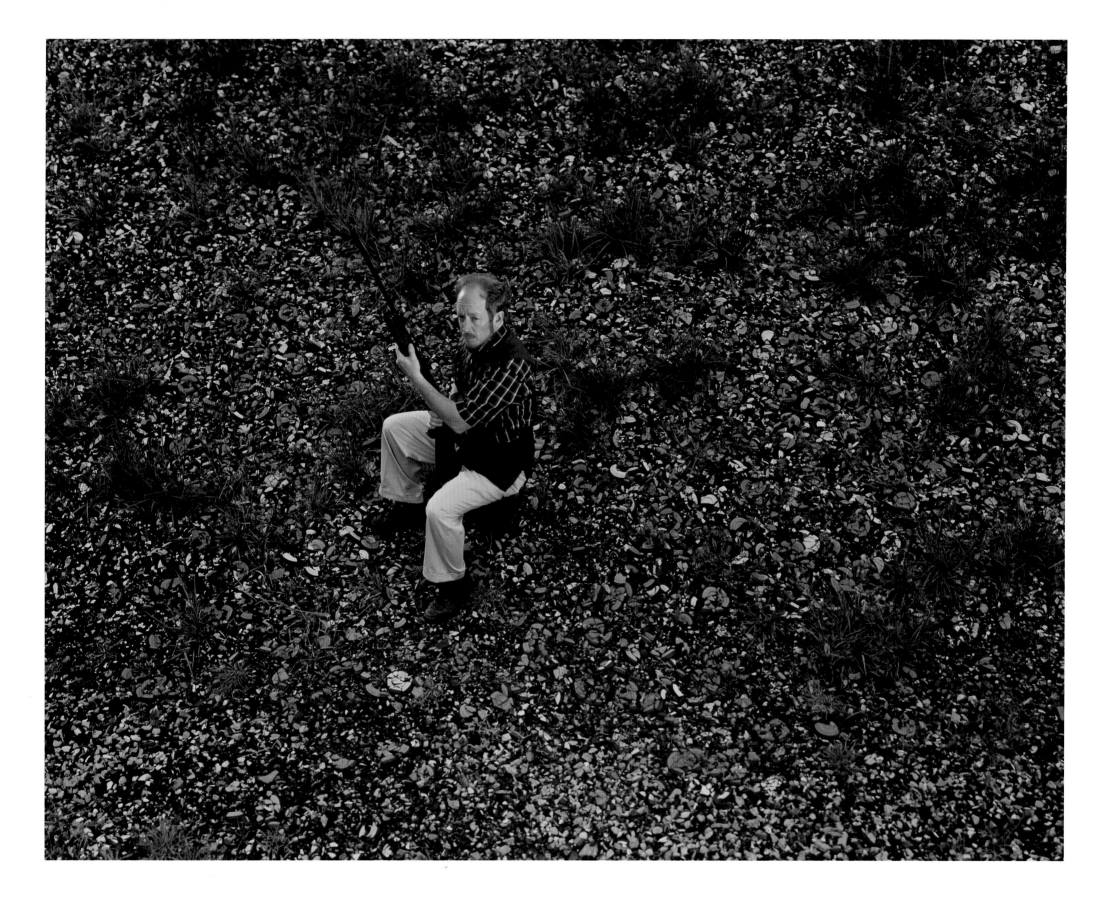

CLYDE CHARLES

Terrebonne Criminal Justice Complex, Houma, Louisiana
Where Charles' brother Marlo is being held
Charles was held here, convicted of the same crime as Marlo
Served 17 years of a life sentence

In March 1981, a Louisiana woman in need of automobile assistance was attacked on the side of the road. The assailant dragged her from the road, beat her with a pipe, and raped her. Later, a policeman picked up the woman and took her to the hospital. The same officer had seen Clyde Charles hitchhiking an hour before the crime occurred and had ordered him off the road. The police picked up Charles and brought him to the hospital, where the victim identified him in a one-on-one showup procedure. At trial, the prosecution presented forensic evidence consisting of two head hairs found on Charles' shirt and semen found in the rape kit. The victim testified that the perpetrator had called himself Clyde. During questioning about a jacket the perpetrator had left behind, Charles' statement, "Was it blue?" was offered as an admission. The defense argued that the cross-racial identification was mistaken, and that Charles had been on his way home from a construction job he worked with his brother, Marlo, who left earlier, walking down the same road. The jury convicted Charles of aggravated rape in 1982, but he continued to maintain his innocence. For ten years, he unsuccessfully sought a DNA test in state court. He finally obtained testing from a federal court seventeen years after his conviction. He was exonerated and released in December 1999. In April 2000, Charles's brother Marlo was arrested for the same crime, and based on the DNA test results, was subsequently convicted.

"That was one of the coldest days of my life. Ten women and two men: all-white jury. I didn't even have a ghost of a chance running through hell with gasoline trunks on.... I don't care who did it. My brother could have done it. Anyone could have done it. It doesn't make no difference—I don't want to go to prison for nobody. The D.A. told me he didn't care if Santa Claus did it, he was going to convict me for it. I said, 'Well, partner, we got a fight on our hands.' After the trial, the girl's father came over to me and he shook my hand. He said, 'For one poor black man, you put up one hell of a fight.' And I looked at him and said, 'Mister, I did not rape your daughter.' He just lightly eased on away. And I looked at my mommy and daddy and said, 'He thinks the fight is over with; the fight's just begun.' " *–Clyde Charles*

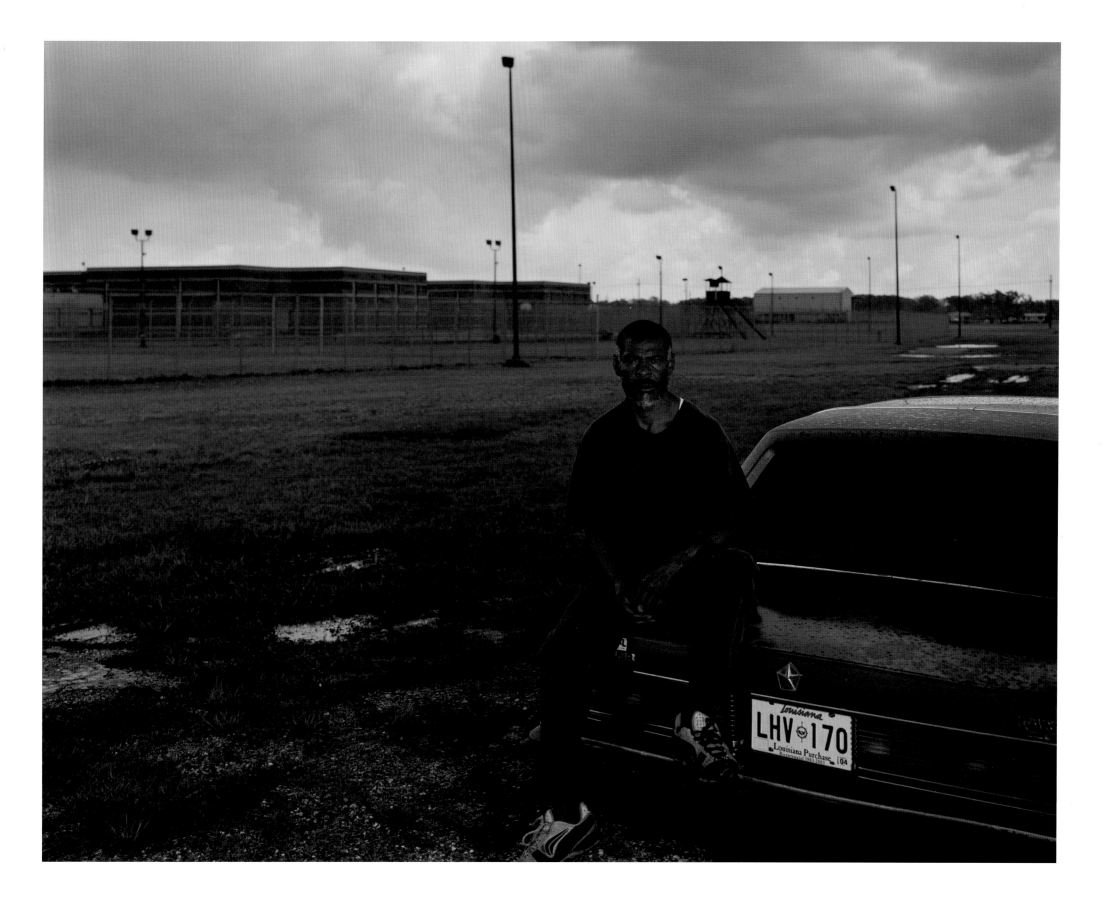

CHRIS OCHOA
Pizza Hut, Austin, Texas
With Jeanette Popp, the victim's mother
Served 12 years of a life sentence

In 1988, Jeanette Popp's daughter, Nancy DePriest, was opening the Pizza Hut she managed in Austin, Texas, when she was tied up, raped, and shot in the head. Money was stolen. Richard Danziger and Chris Ochoa, roommates at the time, worked at a nearby Pizza Hut; they became the focus of the police investigation after they were overheard drinking a toast to the victim and discussing the crime with a security guard at the restaurant. The two men were picked up by police and questioned separately. Following three days of interrogation during which police threatened Ochoa that he would be thrown to prisoners as "fresh meat," lied about Danziger turning against him, and threatened him with execution, Ochoa falsely confessed that he and Danziger committed the rape and murder. Ochoa ultimately pled guilty, taking full responsibility for the shooting, in exchange for a life sentence. In 1990, Ochoa testified in the trial in which Danziger was convicted. Eight years later, Achim Marino, who was serving three life sentences in a Texas prison, underwent a religious conversion and confessed to the crime. He sent letters to then-Governor George W. Bush, the police, the newspaper, and the district attorney directing them where to find the victim's keys, the murder weapon, and the Pizza Hut moneybag he took. His letters went unanswered for two years even though police found what he described. After another letter from Marino made the matter public, Jeanette Popp stepped forward, helping Ochoa and Danziger get DNA tests on semen evidence that excluded them and incriminated Marino. In 2001, Ochoa and Danziger were officially exonerated. Jeanette Popp became an effective activist for reform of the criminal justice system and the abolition of capital punishment. In 2002, Marino was convicted of the murder of Nancy DePriest and received a life sentence.

"I didn't like Bush for a while. He didn't want to help me after he knew I was innocent. He stuck his foot in his mouth too many times—said he had the most perfect justice system in Texas, where he was governor. And all of a sudden here I come up. But, on September 11th, Bush said, 'Look, I have to make sure it's Bin Laden. I have to make sure it was this guy.' They took the time. I like to think maybe Bush learned something. 'Give me time,' he told the people, 'Give me time.' Because they don't want to make a mistake, you know, and punish the wrong people." *–Chris Ochoa*

"I asked the real perpetrator why he killed Nancy and he said because he was a satanic worshipper at that time. He was hearing voices in his head and he had horrible headaches and he thought a human sacrifice would make them go away. She was a satanic sacrifice. I told him you can't send an angel to Satan…. He's not a nice man. And I don't want him out on the street, not ever. But I will not dishonor my daughter by taking another life in her name. She would be furious at the very thought of tainting her memory with his blood—it's not acceptable. It just does no good for anyone. No good for the victim's family. No good for the perpetrator's family…. He wanted to know if I wanted him to live or if I wanted him to die. I don't want him to die. It won't bring Nancy back. If it would bring Nancy back, I'd shoot him myself, right in the head without even blinking an eye. I would not lose a night's sleep. But it won't bring her back. It will just dishonor her. That's all it would do." *–Jeanette Popp*

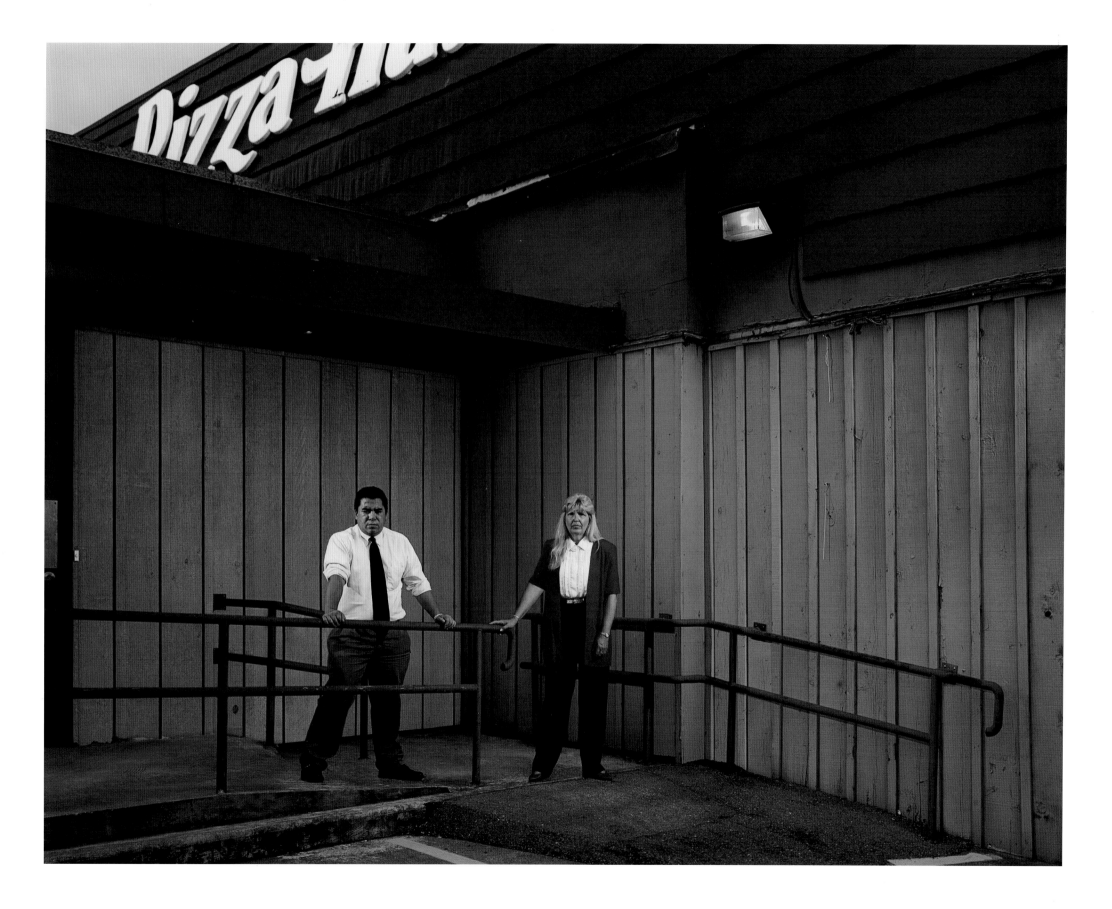

RICHARD DANZIGER

At home, Jacksonville, Florida
With sister and legal guardian, Barbara, and family
Danziger was attacked in prison and sustained serious brain damage
Served 12 years of a life sentence

In 1988, a young woman was opening the Pizza Hut she managed in Austin, Texas, when she was tied up, raped, and shot in the head. Money was stolen. Richard Danziger and Chris Ochoa, roommates at the time, worked at a nearby Pizza Hut. They became the focus of the police investigation into the murder and were picked up by police and questioned separately. Following three days of interrogation Ochoa falsely confessed that he and Danziger committed the rape and murder. Ochoa ultimately pled guilty, taking full responsibility for the shooting, and testified against Danziger at a 1990 trial. Danziger maintained his innocence. He testified that he was with his girlfriend at the time of the murder, but prosecutors claimed that a pubic hair found at the scene belonged to him. Though the semen evidence could not be matched to Danziger, Ochoa could not be excluded. Eight years later, Achim Marino, who was serving three life sentences in a Texas prison, confessed to the crime. He sent letters with detailed knowledge of the crime to then-Governor George W. Bush, the police, the newspaper, and the district attorney. His letters went unanswered for two years even though police found items he had described. After a letter from Marino was made public, Ochoa and Danziger were able to get DNA tests, which excluded them and incriminated Marino. In 2001, Danziger and Ochoa were officially exonerated. By then, Danziger had been attacked in prison by inmates, kicked in the head, and sustained serious brain damage.

Written statement by Richard Danzinger's sister and legal guardian, Barbara:
"On February 27, 1991, Richard's worst fears came true. Another inmate beat the back of Richard's skull into his brain. For many weeks, our family believed he would die. During this time we watched Richard lie unconscious and handcuffed to his bed. Due to this injury, Richard now suffers from seizures, mental problems, and partial paralysis of the left side of his body.... Now, at thirty-two, released from prison, his care has been transferred from the prison system to family members. Richard still has someone making his appointments, taking him to the doctor, making sure he takes his medications, pays his bills. The only difference from being in jail is that now he has people who care about his well being.... My question to you is, where is the justice? If released from prison on parole, you have programs to assist you, find a job, help you find a place to live, groups to help you readjust. With the help of DNA, once you are released, you are on your own. No probation officer, no peer groups, no job assistance, no education, no history or references for job applications. In some cases, no family or friends left to help. Yet society demands you participate and make something of yourself.... So which is better; a place where you eat three meals a day, shower, sleep, make no decisions—or the unknown named freedom? Will Richard ever have freedom or has the justice system robbed him of that opportunity forever?"

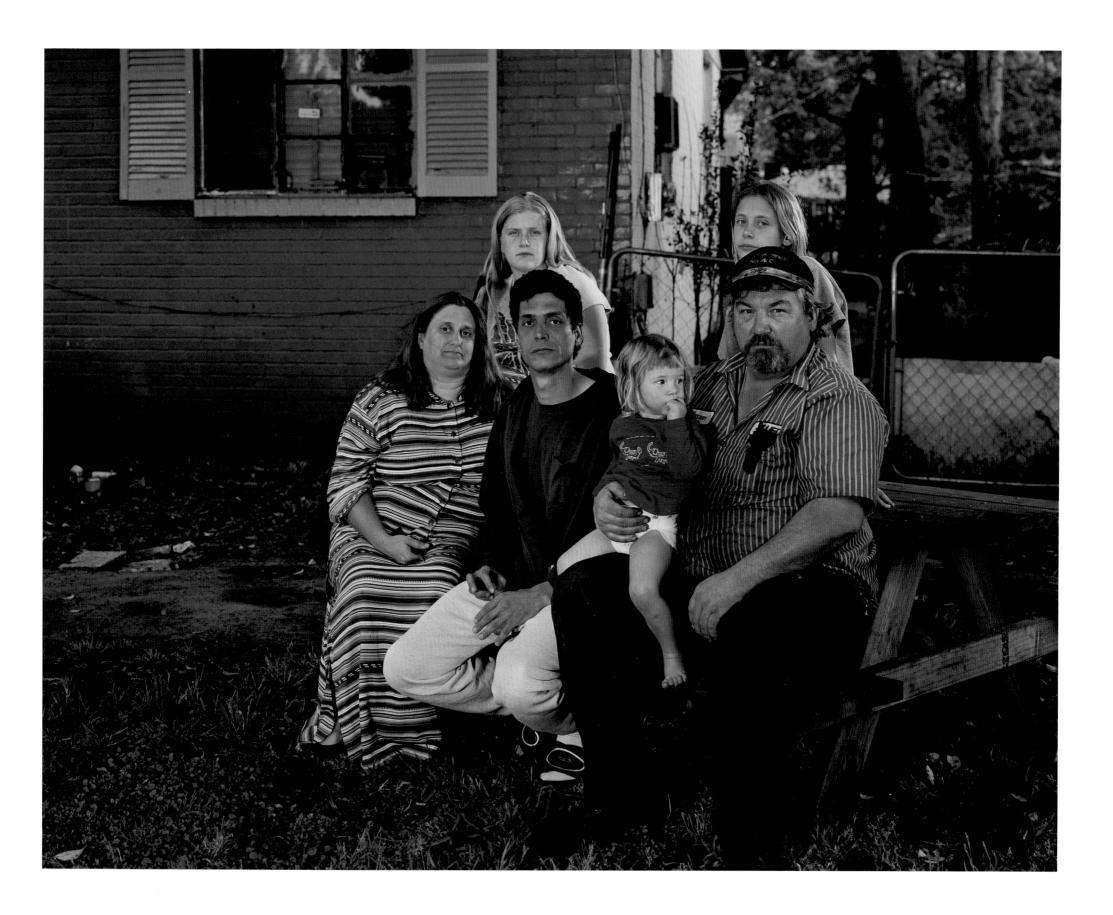

ERIC SARSFIELD
In his bedroom, Bolton, Massachusetts
Served 9.5 years of a 10-to-15-year sentence

In August 1986, in Marboro, Massachusetts, a woman was raped in her home during the afternoon by a man with a small cross tattoo on his arm. After many weeks, the victim tentatively identified Eric Sarsfield's photo from an array as one of two men that resembled her attacker. She was then asked to identify him at the precinct in a one-on-one showup. Sarsfield was asked to wear the jacket left by the rapist at the scene of the crime and to say things the rapist had said. The victim was still not certain. The next day, she was asked to view the photo array with Sarsfield's picture again. Finally, after the victim said she was certain, Sarsfield was indicted and brought to trial. He had no tattoo on his arm. Just before trial, however, a police officer claimed Sarsfield volunteered that he used washable tattoos. Sarsfield was convicted in July 1987. In prison, Sarsfield maintained his innocence and refused to admit guilt, despite the fact that an admission would have meant an earlier release on parole. Sarsfield was released on parole in June 1999. Although he had filed a motion seeking DNA testing of semen from rape kit evidence in 1997, testing did not occur until March 2000, nearly one year after his supervised release as a sex offender. The results were found to exclude Sarsfield. He was exonerated in August 2000.

"What ten years of your life would you want gone? One to ten? Ten to twenty? Twenty to thirty? Well they got me from twenty-six to thirty-seven.... You feel like somebody owes you something. But nobody has nothing for you. So you do it yourself, like you were always taught to.... I try to live like before, but I can't live life as full as I'd like to. You know, going out, playing pool and dancing some nights would be nice. But I can't go out because I really think that someone could recognize me, or someone could say something to somebody else, or something like that—something could happen, something could happen...." *–Eric Sarsfield*

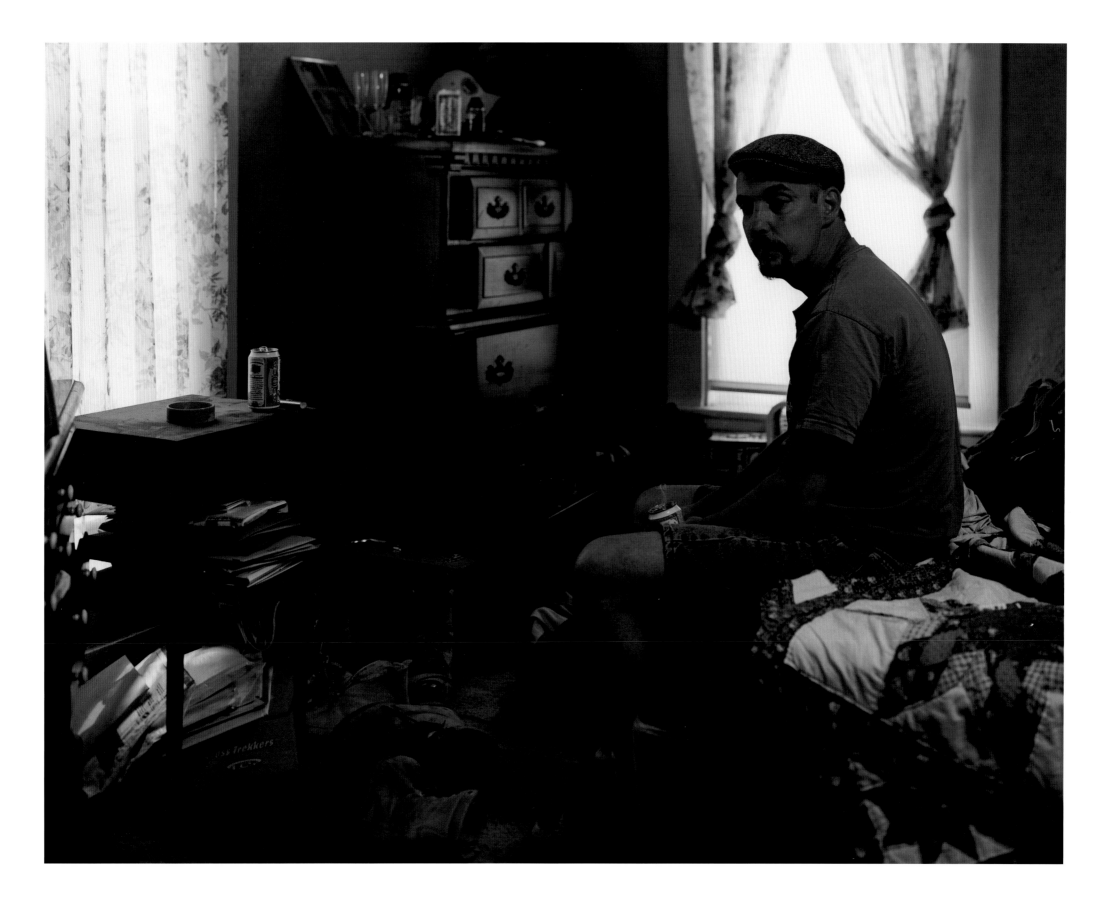

RONALD COTTON
With victim Jennifer Thompson, Winston-Salem, North Carolina
Served 10.5 years of a life sentence

In July 1984, two women in the Burlington, North Carolina area were raped after a man broke into their apartments, cut their phone lines, and robbed them. The first victim identified Cotton's photograph and then picked him out of a lineup. In 1985, he was prosecuted for the first rape and convicted. The case was later reversed because the trial court had not allowed evidence that the second victim had picked another person in a lineup. This evidence would have enhanced the defense argument that someone other than Cotton had committed both rapes. In 1987, the case was brought to retrial. This time, the prosecutor charged Cotton with both rapes. Shortly before the second trial, another inmate serving time in the same prison where Cotton was housed boasted that he was responsible for both rapes. Although the second inmate was presented in court, the victims failed to identify him as the perpetrator. Despite the earlier misidentification in the lineup, the second victim identified Cotton before the jury. In addition to the in-court identifications, the prosecutor also presented a flashlight, said to resemble the assailant's, and shoe rubber from Cotton's sneakers that was consistent with marks found at the crime scene. Cotton was convicted of both rapes. Eight years after his second trial, DNA testing of rape kits excluded Cotton. When the profile from the evidence was compared to a state convicted offender database, a match was produced with the inmate who had boasted of the crime, been presented, but not identified at the second trial. In May 1995, the charges against Cotton were dismissed. He was released in June 1995 and officially pardoned that July. Ronald Cotton and the victim, Jennifer Thompson, have forged a friendship since the exoneration. Thompson has become a public voice about the dangers of eyewitness identification.

"Time went by and Poole was processed within the system. Occasionally, some of the prison staff would call me Poole. I would tell them that I'm not Poole. I'm Cotton. I didn't like the fact that they got us mixed up like that…. I made up my mind that I couldn't tolerate this guy being in the same housing area that I was in. He'd been bragging about having me incarcerated for a crime he had committed. It was just eating at me. I decided that I was going to get this guy. I had a piece of metal. I took my tee shirt, wrapped it around it. I took duct tape to make it fit tight so I would have a nice handle. About a week later I had a visit from my father and I told him my intentions. He told me that I wasn't guilty of the crime but if I took this next man's life, I would be in there for life. My dad was telling me the truth. I took the weapon and got rid of it. Eventually, I was transferred to another unit. And I never saw Poole any longer." *–Ronald Cotton*

"After the rape, I went to the police department. They asked me if I thought I could identify my attacker. I said yes. They asked if I could do a composite sketch. I sat down with a police artist and went through the book. I picked out the nose, the eyes, and the ears that most closely resembled the person who attacked me. It ran in the newspaper the following day. From that composite sketch, a phone call came in that said the sketch resembled someone they knew: Ronald Cotton. Ron's name was then pulled, and he became a key suspect. I was asked to come down and look at the photo array of different men. I picked Ron's photo because in my mind it most closely resembled the man who attacked me. But really what happened was that, because I had made a composite sketch, he actually most closely resembled my sketch as opposed to the actual attacker. By the time we went to do a physical lineup, they asked if I could physically identify the person. I picked out Ronald because in my mind he resembled the photo, which resembled the composite, which resembled the attacker. All the images became enmeshed to one image that became Ron, and Ron became my attacker." *–Jennifer Thompson*

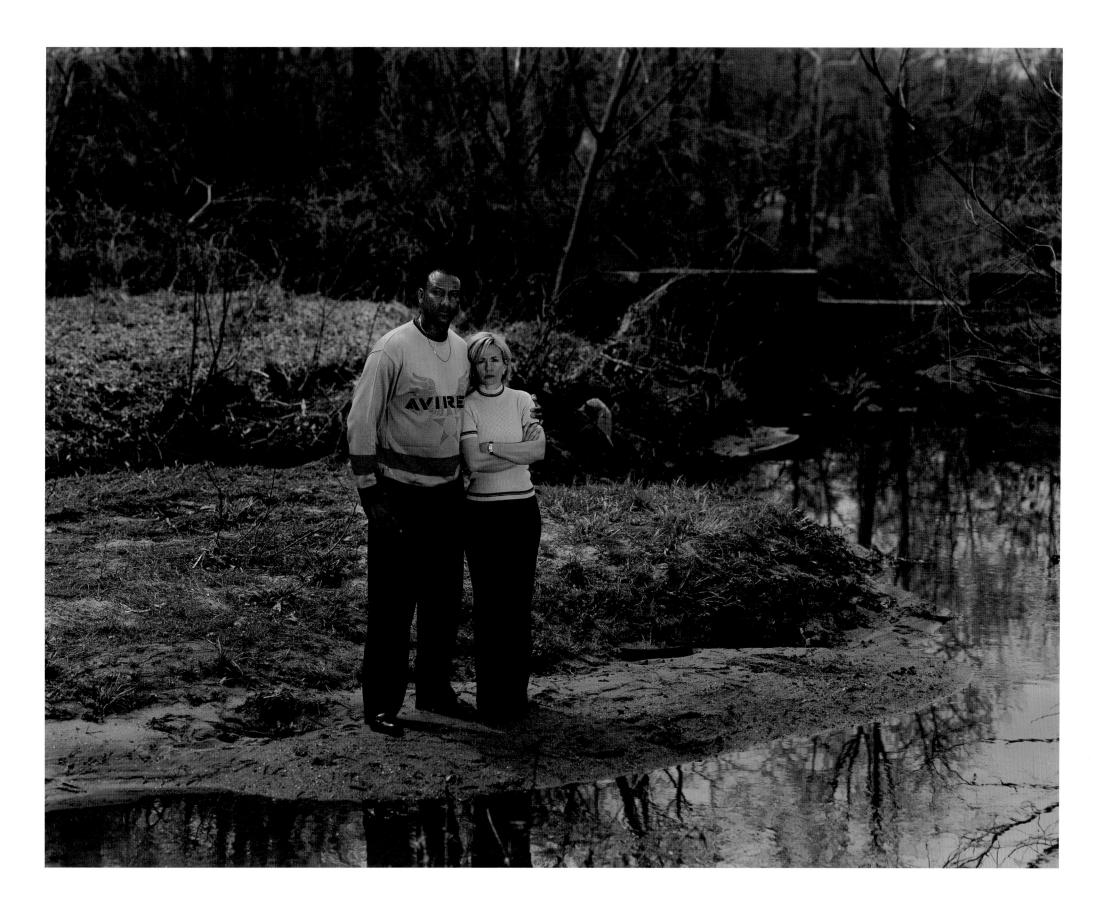

EDUARDO VELAZQUEZ

Scene of the crime and misidentification, Chicopee, Massachusetts
Velazquez was identified from 25 feet away, illuminated by one flashlight
Served 13 years of a 12-to-18-year sentence

In December 1987, a young woman in Chicopee, Massachusetts was assaulted and raped as she was entering her car after an evening class. The assailant forced her to perform sexual acts at knifepoint and ejaculated on her coat, hair, and face. The victim ran into a school building and summoned the police. Her description of the perpetrator was then broadcast to police in the area. At about the same time, other Chicopee police officers detained Eduardo Velazquez for stopping his car in a "drug-prone location" several blocks from the nursing school. When the description of an Hispanic male came over the radio, they asked Velazquez to accompany them to the scene of the rape. The victim stood inside the building, peering from behind two officers and two sets of closed doors while another officer shined a flashlight on Velazquez's face as he waited outside. At first, the victim offered a tentative identification, but became more confident after hearing his voice and inspecting his gloves. At the 1988 trial, the prosecution also presented serology results from testing on semen and a pubic hair comparison that could not exclude Velazquez. Velazquez attempted to support his defense of misidentification with an alibi provided by the police who had detained him. His attorney's request for computer printouts of the time that the police officers stopped Velazquez went unanswered, and the officers testified at trial that they had not detained him until after the rape had concluded. Convicted on all counts, Velazquez remained in prison for thirteen years before an appellate court ordered a reluctant district attorney to permit DNA testing. Once the DNA testing on the woman's semen-stained coat excluded him, Velazquez was exonerated and released in August 2001. Finally in 2002, the Chicopee police located a computer printout from 1987 that supported his alibi.

"You feel like you've been thrown in a big hole with no ending. It's like you have this little voice that nobody wants to hear and you're screaming out so loud, and people, they don't want to listen. You've been convicted. You've been tried. You've had your day in court. You've been tried by a jury of your peers, so they say, but I wasn't tried by a jury of my peers. I was tried by an all-white jury…. There's no such thing as a perfect system because it's man-made laws, not God-made laws. There's always going to be loopholes and there's always going to be cracks. But it's up to those who have people's lives in their hands to fill those loopholes and cracks." *–Eduardo Velazquez*

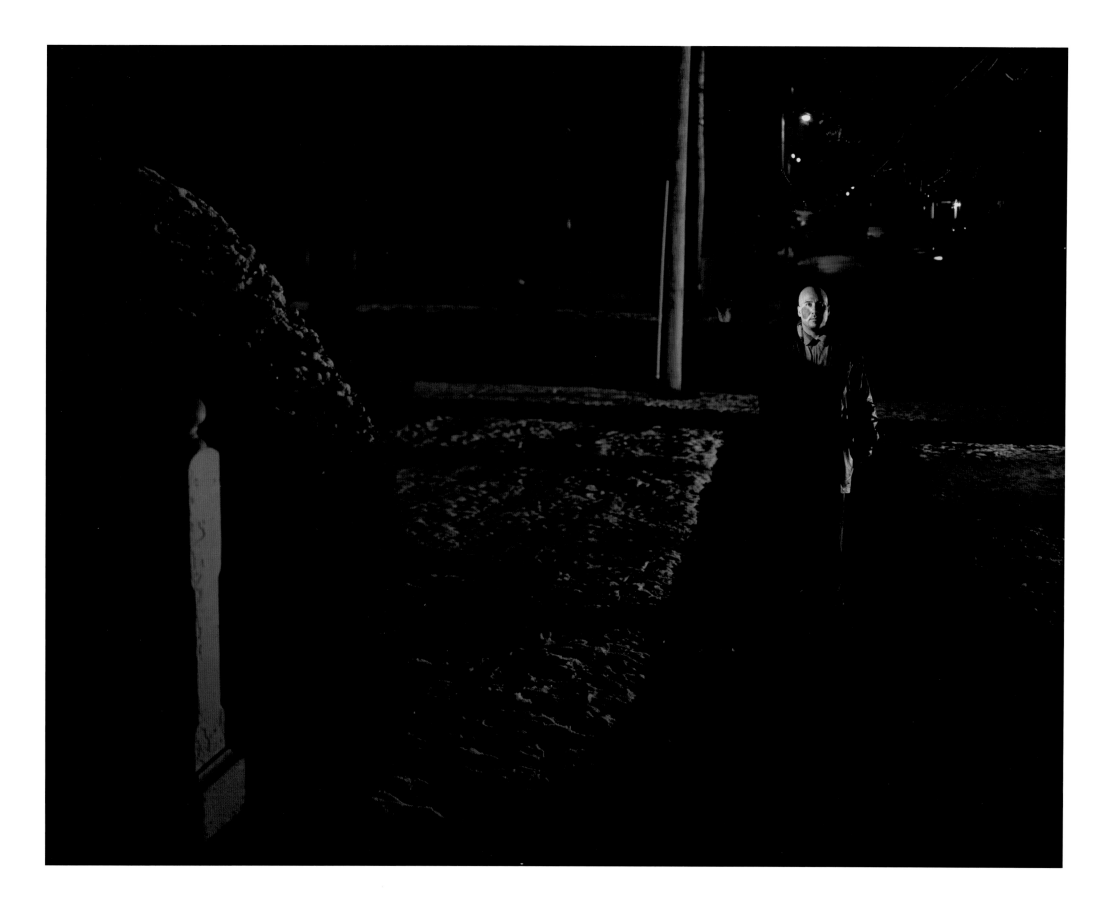

KEVIN GREEN

Army aviation facility of the National Guard, Jefferson City, Missouri
Green was arrested in uniform while on duty
Served 16 years of a 15-to-life sentence

On September 30, 1979, a nine-month-pregnant housewife was brutally beaten and raped in her home in Tustin, California. Her injuries resulted in the loss of the child she was carrying as well as brain damage and amnesia. Sometime after she regained consciousness, she remembered that it was her husband, Kevin Green, a corporal in the Marines, who was responsible for the attack. Green was indicted for the murder of the baby and the attempted murder and rape of his wife. At trial in 1980, Green testified that he had gone to a Jack In The Box restaurant to pick up food when his wife was being attacked. His claim was verified by an employee at the restaurant and by police officers, who had found the food still warm when they arrived at the scene. The prosecution's case hinged on the victim's testimony, which suggested that Green flew into a rage when she refused to have sex with him. The state's psychiatrist established her as a credible witness, though she had suffered extensive brain damage. Although Green was initially charged with first-degree murder, a capital offense, he was convicted of murder in the second degree and sentenced to life. Sixteen years into his sentence, detectives visited another inmate, Gerald Parker, who matched DNA evidence from an unsolved murder. When Parker was confronted by the detectives, he offered an unsolicited confession for Kevin Green's case. Eventually, the detectives found the rape kit which excluded Green and matched Parker. Parker was known as the "Bedroom Basher," a serial killer who broke into bedrooms to rape and kill. He eventually confessed to five other murders. Kevin Green was exonerated and released in 1996.

"During that trial, we listened to the prosecution prove I was innocent, prove that I was somewhere else, prove that the murder weapon wasn't the murder weapon, proved my defense 100 percent. The jury heard only Diane saying it was me…. Everybody who goes to prison fantasizes about escaping—whether it be by suicide or by going over the wall, under the wall, through the fence, out in the laundry truck, or whatever. One guy and I had envisioned trying to get a hold of old Marine buddies and having a helicopter gunship come in, land in the yard, take out the towers, and we'd escape. But all that's fantasy. All that's just a way to try to stay sane." *–Kevin Green*

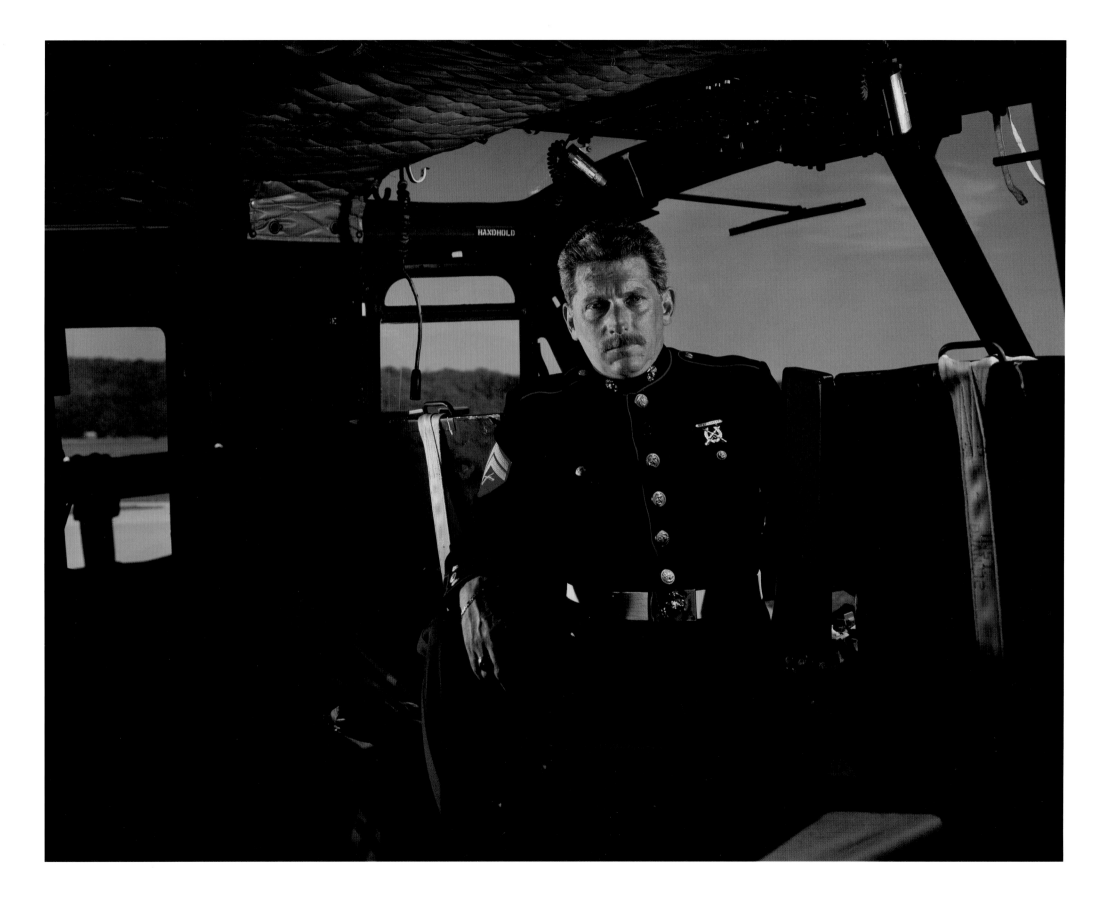

RONALD JONES
Scene of arrest, South Side, Chicago, Illinois
Served 8 years of a death sentence

On March 10, 1985, a twenty-eight-year-old woman who went out late at night to look for a Harold's Chicken restaurant was found raped and stabbed to death in an abandoned building on Chicago's South Side. Later that year, police produced a confession signed by Ronald Jones after a twelve-hour interrogation. At the time, Jones was an alcoholic and living in abandoned buildings. According to the confession, Jones had sex with the victim and then subdued her after she attacked him. Jones said that the confession was the product of police coercion which included physical assault. Based on the confession, Jones was convicted of rape and murder and sent to death row. Initial DNA testing on the semen recovered from the victim was deemed inconclusive. In 1994, Jones requested that the trial judge authorize DNA testing with newer methods, but the request was denied. In 1997, PCR-based DNA testing was used by order of the Illinois Supreme Court, and the results excluded Jones as the perpetrator. His conviction was vacated in July 1997, and Jones was granted a new trial. Jones remained incarcerated until May 1999, when, after reinvestigating the matter, prosecutors officially announced that the charges were dropped. Jones was subsequently pardoned on the grounds of innocence.

"They wouldn't even ask for the death penalty for O.J.. But why was that? Because O.J. had money, he was a celebrity. But me? I couldn't even afford an attorney. O.J. had lawyers people dream about having. Me? If a public defender wouldn't have been free, I wouldn't have even had that. You're not gonna see no rich people on death row, very few of them even go to jail. I have not—to date—seen a rich man go to death row.... It's two types of justice: there's a poor man's justice and a rich man's justice.... I was poor and still is. I'll never be able to feel free. Because as long as I'm poor, the same thing that they did to me in 1985, they can do it to me again." *–Ronald Jones*

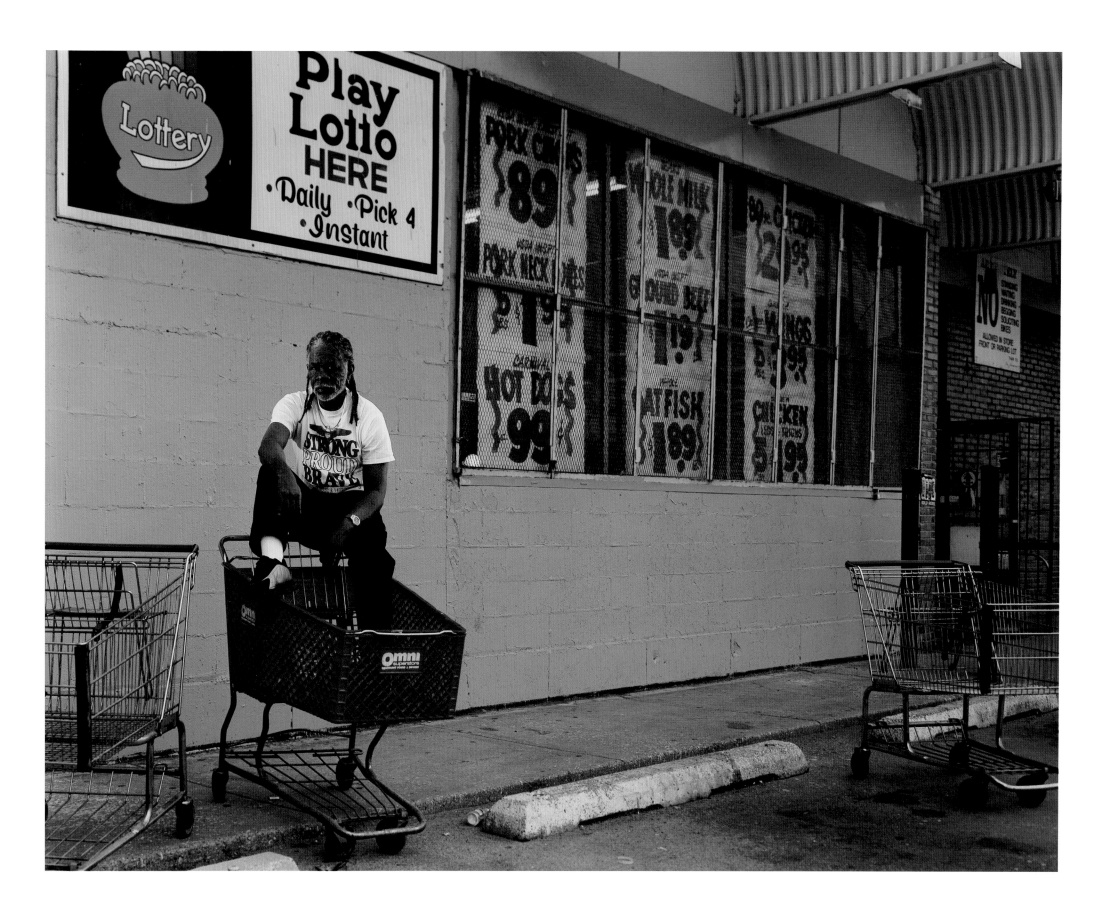

ROY CRINER
Alibi location, Houston, Texas
Served 10 years of a 99-year sentence

In September 1986, the body of a young woman was found near a road in Montgomery County, Texas. She had been raped and had died of stab wounds to the neck and blunt trauma to the head. The police investigation centered on Roy Criner, who had been overheard telling friends that he had picked up and slept with a young woman hitchhiker in the area. These statements, as well as results from serological testing of semen recovered from the victim's vaginal and rectal samples, led to Criner's conviction of aggravated sexual assault in 1990. Other forensic evidence introduced included a cigarette found near the body, a clump of hair found in the victim's hand, and her clothing. Criner's alibi was that he was working at a logging site at the time the crime was committed. Years after his conviction, DNA testing on the spermatozoa evidence excluded Criner. The Texas Court of Criminal Appeals, however, found that this was not enough evidence to exonerate him. The Court proposed possible explanations for the exclusion, claiming that the victim could have engaged in prior consensual sex or that Criner could have used a condom. None of their proposed theories had ever been presented at trial or in any appeal. Criner then obtained DNA testing on the cigarette butt found near the victim's body, which revealed at least one male and one female profile. The victim's profile matched the female portion and the male portion matched the semen donor, proving that the victim shared a cigarette with the man who raped her just before her death. On the strength of this evidence, Criner was finally issued a pardon by the governor on August 14, 2000 and released.

"The first time it really slapped me in the face, I was going down the freeway in a car with the windows rolled down, the radio blasting, and the wind was blowing and I just started crying. I felt free—you know what I'm saying? And I said, 'I'm free.' But most of the time I'm paranoid. Who's gonna be around the corner tomorrow morning when I go to work? Sometimes I spit on the ground and say, 'Well maybe they'll scrape that up and put it on a crime scene.' They had me ejaculate in a cup and said the vial got broke. They came back and got blood and all this other stuff. You know, there's a lot of me that's still out there somewhere." *—Roy Criner*

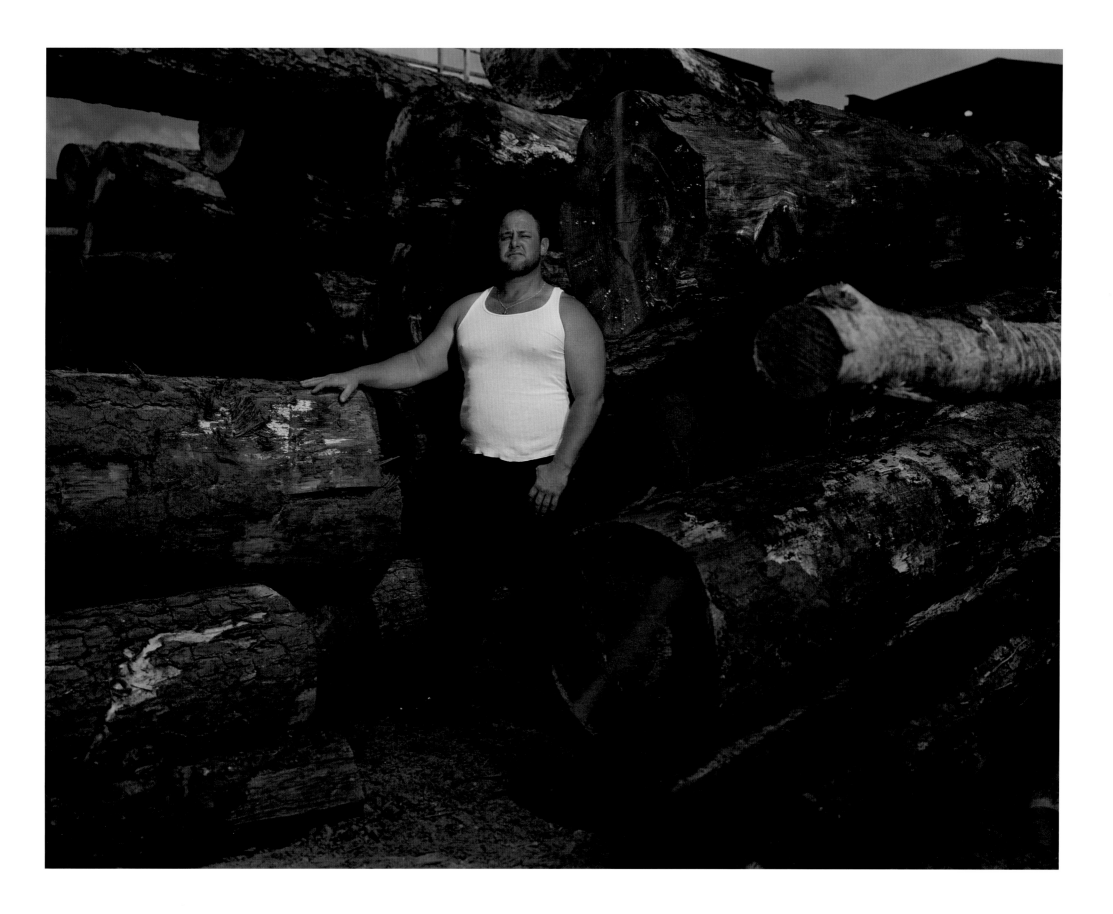

WARITH HABIB ABDAL
125th Street, Harlem, New York, where Abdal grew up as "Vincent Jenkins"
Abdal converted to Islam and changed his name in prison
Served 17 years of a 20-to-life sentence

In May 1982, a young woman was raped in a nature preserve in Buffalo, New York. Warith Habib Abdal, then Vincent Jenkins, was picked up more than four months after the crime occurred and presented to the victim in a one-on-one showup procedure. The victim failed to identify Abdal, even though the police told her that Abdal was their key suspect. She then viewed an old photograph of Abdal, returned to the showup, and finally identified him as her attacker. Despite this suggestive identification procedure, despite significant differences between the victim's initial description of the suspect and Abdal, and despite alibi testimony corroborated by work records, Abdal was convicted of rape in 1983. Ten years later, Abdal obtained an early form of DNA testing that yielded inconclusive results. (The test lacked the power to discriminate between more than one contributor of sperm, and the victim claimed she had had consensual sex prior to the rape.) In 1999, hoping that new DNA techniques would work, Abdal's lawyers sent slides and swabs to a private laboratory. The evidence was lost by an overnight mail service. Miraculously, DNA extract from the 1993 testing was found, even though that laboratory had ceased performing forensic testing. Testing of the 1993 extract revealed two male contributors. Abdal was excluded as the source of either profile. Based on this new evidence, Abdal was exonerated and released in September 1999.

"They say I'm the one that's crazy. Ain't that deep? United Snakes, I mean States of America. 'Scuse me, my teeth are loose. They kicked them out in Attica when I was busted for rape. My understanding of the five points of the star: an officer grabbed this leg, one grabbed this leg, one grabbed this arm, another grabbed this arm, and the fifth one stepped between my legs and kicked me in my groin until I bled from the mouth. And the tax dollar paid for that. Didn't you know that? I did seventeen years and they want to give me a dollar and a half and take seventy-five cents of that. All I've asked out of this madness is for three graveyards. One in Clinton, where they murdered my brother, one in Sing Sing, and one in Attica. So when they finish killing brothers in the penal system, at least they can be buried as Muslims.... United Snakes of America is not at war with terrorists. 'Cause if she were, she'd kill the terrorists in this country first. And that's the Ku Klux Klan—my terrorists. Anybody leaving this country—going to another country, talking about fighting the terrorists—you better think twice. Because the war that was before this, the men that lost it, they're in the penitentiary. My evidence is in the penitentiary." *–Warith Habib Abdal*

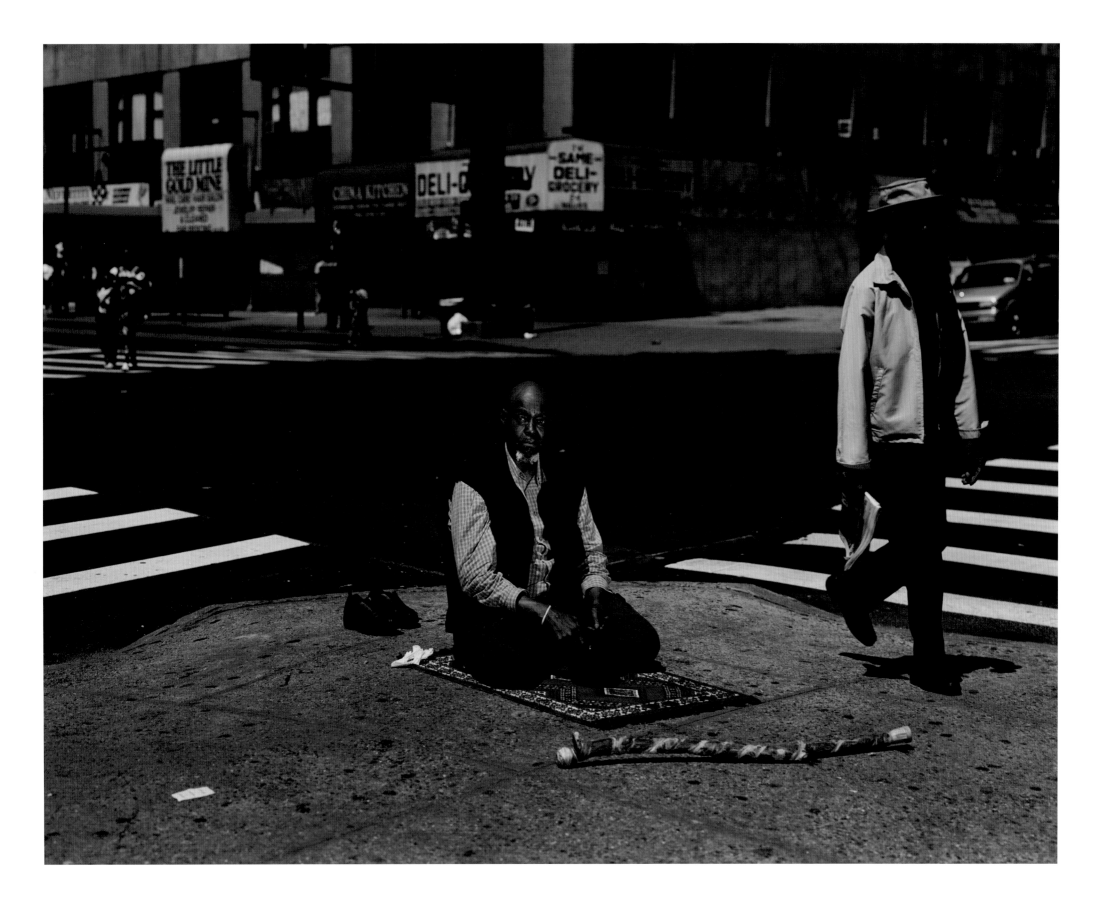

CALVIN WASHINGTON
C&E Motel, Room No. 24, Waco, Texas
Where an informant claimed to have heard Washington confess
Served 13 years of a life sentence

In March 1986, the body of a Waco, Texas woman was found in her home. She had been beaten, strangled, and raped. Calvin Washington was arrested for the murder based on the theory that he, alone or acting in concert with Joe Sidney Williams, killed the victim in the course of a robbery and sexual assault. Prosecutors presented evidence that the two defendants were in possession of property that belonged to the victim. Witnesses also testified that Washington had made inculpatory statements regarding the burglary. From Washington's home, police seized a shirt that had blood on it, supposedly the victim's. As a result, Washington was convicted of capital murder in 1987. DNA tests proved that the blood on Washington's shirt did not belong to the victim. Testing on semen evidence also proved that neither Washington nor his co-defendant had raped the victim. Based on these exculpatory test results, Calvin Washington was pardoned in October 2001. The DNA profile from the rape kit inculpated another suspect named Bennie Carroll, who had committed suicide. Carroll had previously admitted to raping and beating one of the victim's neighbors.

"When I got to Highway 6, after leaving jail, I found out my mom was dead. She'd been dead for about two years. No one told me. They said they couldn't get in contact with me. But they knew where I was. It bothers me. I think about it all the time. I go visit her grave. I kept writing her, but nobody ever wrote me back or told me nothing. I found out when I got out. At first, I thought the letters weren't getting out. None of them came back. Somebody had to be throwing them out. She never wrote me back. And then, when I got out, they told me she was dead." *—Calvin Washington*

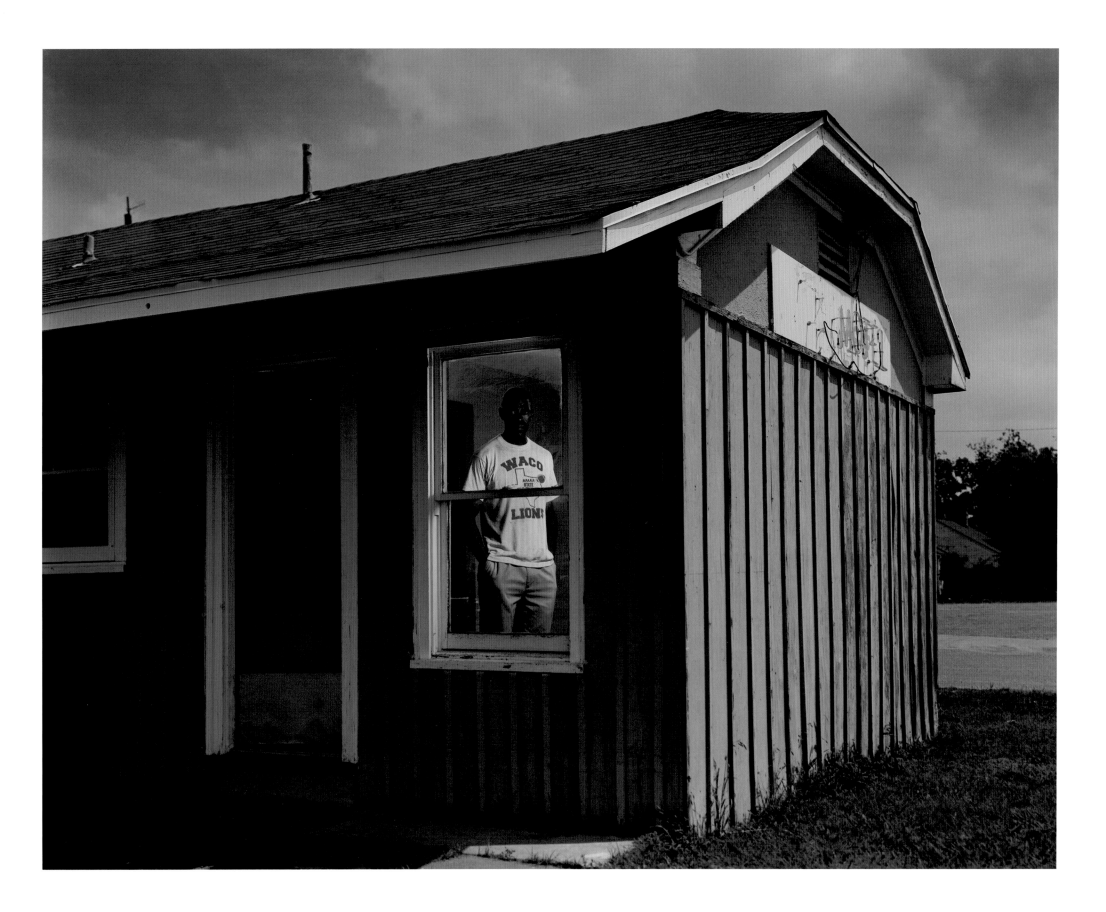

EDWARD HONAKER
Scene of the crime, Blue Ridge Mountains, Virginia
Wearing the camouflage that the prosecution used against him in court
Served 10 years of a life sentence

In 1984, in rural Virginia, a young couple was attacked while sleeping in their car. The assailant posed as a police officer and ordered them out of the car at gunpoint. The woman was forced into the assailant's truck; her boyfriend was forced into the woods. The assailant then drove the woman to a different area and raped her repeatedly. After being hypnotized, the victim made a composite sketch. A police officer in Roanoke thought the sketch looked like Edward Honaker. The couple eventually identified him as the perpetrator in a photographic array. They also identified his truck as being similar to the assailant's. Other evidence included camouflage clothing resembling the assailant's, found at Honaker's house, and a hair from the woman's clothing that the state's expert said matched Honaker. Honaker's alibi defense was corroborated by three witnesses. Despite evidence that Honaker had had a vasectomy years earlier and could not have produced the semen recovered from the victim, he was convicted of multiple counts of sexual assault, sodomy, and rape. Nearly ten years later, Honaker secured access to the evidence and DNA testing. The prosecution predicted that the semen found would belong to the boyfriend or a previously undisclosed lover. Several rounds of DNA testing revealed that the semen did not belong to Honaker, the boyfriend, or the secret lover. Based on these results, Honaker was pardoned in October 1994 by Governor George Allen on the grounds of innocence.

"Timothy Spencer, *aka* 'the Southside Strangler,' was convicted solely on the basis of DNA evidence. Not only was he convicted, he was ultimately sentenced to death. I followed this from day one because I knew if Timothy Spencer was put to death by the State of Virginia based solely upon DNA, that they would have to exonerate me. I just knew that. I won't say that I rejoiced the night they killed Timothy Spencer, but I did breathe a sigh of relief. Because I knew then that DNA was definitive, that it was the ultimate tool in law enforcement in the State of Virginia. If you're gonna find someone guilty then you have to find them innocent. It cannot be a one-way tool. It has to go both ways.... There is no perfect system. Maybe it sounds really strange saying it, but it's still the best damn system we have. There has to be law and order. Until someone offers something better, I don't know what they can do. I guess I can say this because I'm sitting here with you, instead of talking with you between bars. But, you know, there are casualties of war." *–Edward Honaker*

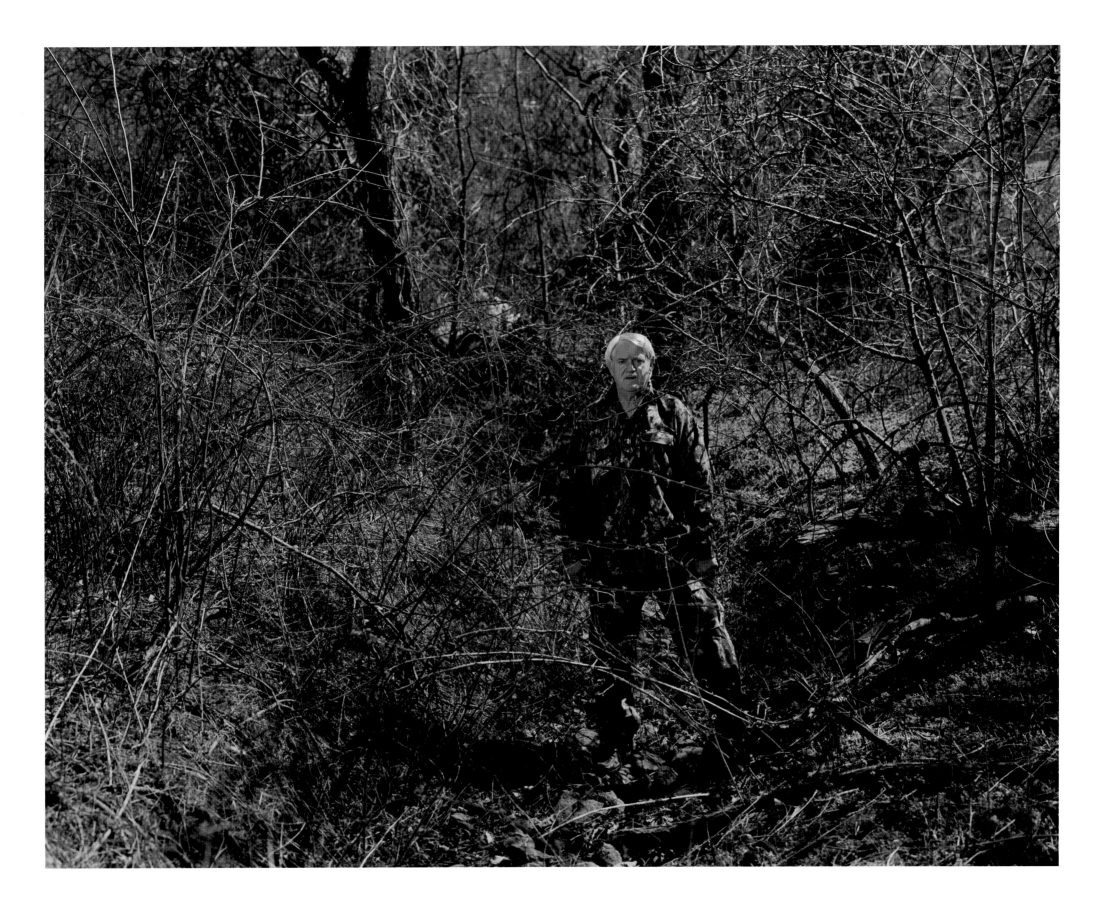

VINCENT MOTO
Scene of identification and arrest, Philadelphia, Pennsylvania
With son André, who was with Moto at time of arrest
Served 8 years of a 12-to-24-year sentence

In December 1985, a woman walking along a street in Philadelphia, Pennsylvania was attacked when two men in a car pulled up beside her. The passenger got out, threatened her with a gun, and forced her into the car. After driving to another location, both men robbed and raped her. Then they forced her out of the car, half-clothed, and fled. Five months later, the victim saw Vincent Moto walking with his three-month-old son and identified him as one of the perpetrators. He was detained and arrested. In 1987, Moto was convicted of rape, involuntary deviate sexual intercourse, criminal conspiracy, and robbery on the basis of the victim's identification. Motions requesting DNA testing were filed shortly after the verdict. Though these requests were denied, the court did ensure that the evidence would be preserved. Seven years later, DNA testing proved that Moto was not involved in the crime. He was released in July 1996, though the prosecution still sought another round of testing. Subsequent independent testing in 1998 verified the original findings.

"My son is angry. I know he is. He was robbed, growing up without his father there. He'd come to see me and ask me, 'Why are they keeping you here? When are you coming home?' When it was time to leave he'd be crying, holding onto my leg, saying, 'No! Don't take my dad away ... let him come home.' He was always confused: 'Dad, if you didn't rape this woman, then why do they keep holding you here?' It put double-thoughts in his mind— 'Maybe my dad is lying and he did rape this lady? This is why they're holding him in prison.' Then, when I was released, he was happy to see me, but he's eleven years old. 'I'm home son.' And he's like, 'Hi, Dad.' Like he doesn't even know me: 'Who is this guy? I never spent no time with him. I never went anywhere with him. I never did anything with him—unless it was behind a wall, or in a room where he might have gone to the snack machine and got me a bag of peanuts, or colored a coloring book with me. But who is this guy? I don't even know this guy.' " *–Vincent Moto*

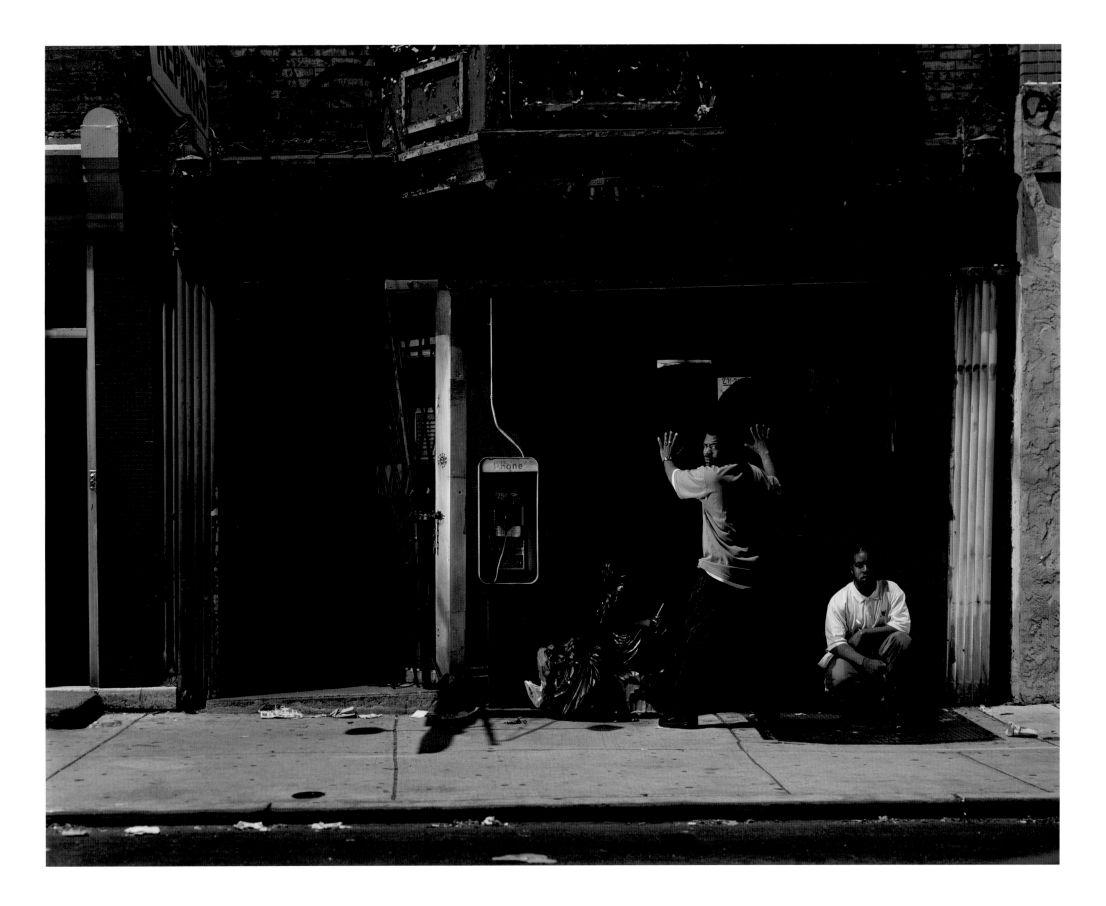

HERMAN ATKINS

Los Angeles Southwest Community College, Los Angeles, California
Atkins, 36, is currently enrolled as a freshman and plays college football
Served 11.5 years of a 45-year sentence

In April 1986, a shoe-store clerk in Lake Elsinore, California, was raped and robbed at gunpoint. Before getting dressed, the assailant wiped the semen from his genitals onto the victim's pink sweater. After contacting the police, the victim was shown yearbooks from Elsinore High School but was unable to find a picture matching the assailant. She was then taken to a briefing room in the police station, where she saw a wanted poster with a sketch of Herman Atkins. The victim identified Atkins as the perpetrator, which lead to his arrest and 1988 conviction for forcible rape, forcible oral copulation, and robbery. At trial, Atkins argued that the victim's cross-racial identification was mistaken. The prosecution bolstered the identification with serology results from semen left on the victim's sweater. The state serologist falsely testified, and the prosecutor argued to the jury that 95 percent of the male population were excluded as potential semen donors. In fact, the crude testing available in 1987 failed to exclude anyone. In 1999, after years of litigation and resistance from prosecutors, Atkins won access to the biological evidence. DNA test results excluded him as the source of the semen on the sweater. In February 2000, Herman Atkins was exonerated and released from prison.

"I know what my ancestors felt like when slavery was abolished. Three hundred to four hundred years of slavery and then all of a sudden one day it's over with and you're told— go into society and function the best way you can. Well, what society did to me was they told me: 'Here's $200. Get the hell out of our prison, go into society and function the best way you can.' When I come into society and try to get a job I then realized that you need some kind of training to mop a floor.... I'm going to always be a step behind. You can't catch up. I'm gonna always be a step behind." *–Herman Atkins*

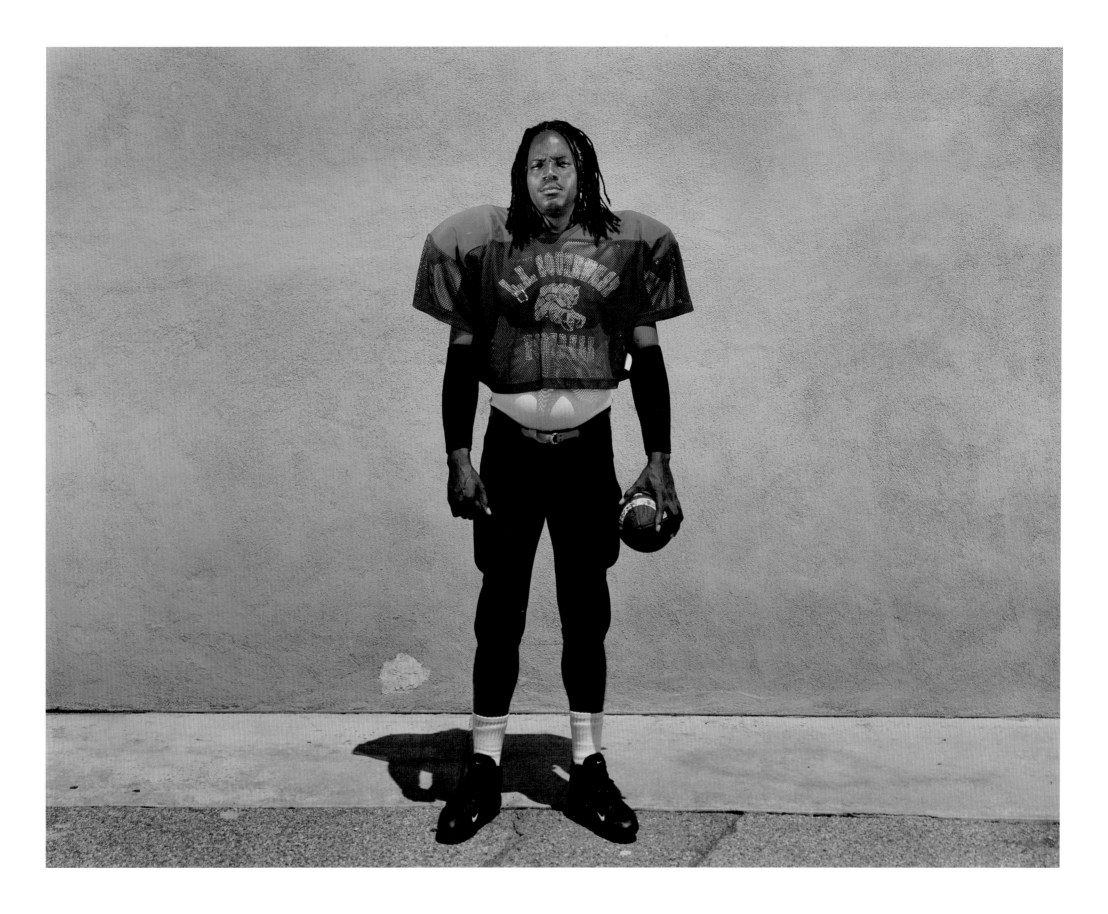

CARLOS LAVERNIA

Texas County Correctional Facility, Austin, Texas
Lavernia remains incarcerated by the INS and is fighting extradition to Cuba
Served 15 years of a 99-year sentence

In June 1983, a young woman in Austin, Texas was raped at knife point. The assailant attacked her as she was jogging, dragged her off the trail, struck her in the head, and raped her. She described the assailant as a Hispanic male in his mid-twenties who stood about 5'6, and she gave details about his clothing. After helping police produce a composite sketch, the victim identified Carlos Lavernia in a live lineup. Later, she testified that Lavernia was the only person in the lineup who even resembled the police sketch. A Cuban immigrant, Lavernia spoke virtually no English at the time of his 1985 trial. He presented a defense of actual innocence, but was convicted of aggravated rape. Fifteen years later, Lavernia gained access to the biological evidence for DNA testing, which exculpated him and exonerated him in 2000. Lavernia remains incarcerated on an INS detainer and is fighting extradition to Cuba.

"When I be in the trial—I no speak English before—I don't know what's going on in the court. I don't know what's happening. I think I'm going home, because I never did the crime. America is a good country, but not Texas. But I don't want to go back to Cuba; I'd rather die in prison in America. Castro treated me bad over there.... I haven't seen my mama for twenty-two years. She wrote me in 1987 and she asked me, 'What you doing in the penitentiary?' I no write back to my mama 'cause I no want to lie to her. I never write back. I no want to tell her what kind of case I have over here.... The first thing I want to do if I get out is write my mama and tell her, 'I'm a free man.' I don't know if she's still alive or not. The last time I heard from her was 1987, but I never wrote back. Now, I'm writing her again saying, 'I love you and I miss you.' But nobody answered my letters. And now my lawyer wrote a certified letter. I don't know. Maybe the government don't want to give it to my mama. Sometimes I wish my lawyer didn't send the letter because I don't want to see that my mama died." *–Carlos Lavernia*

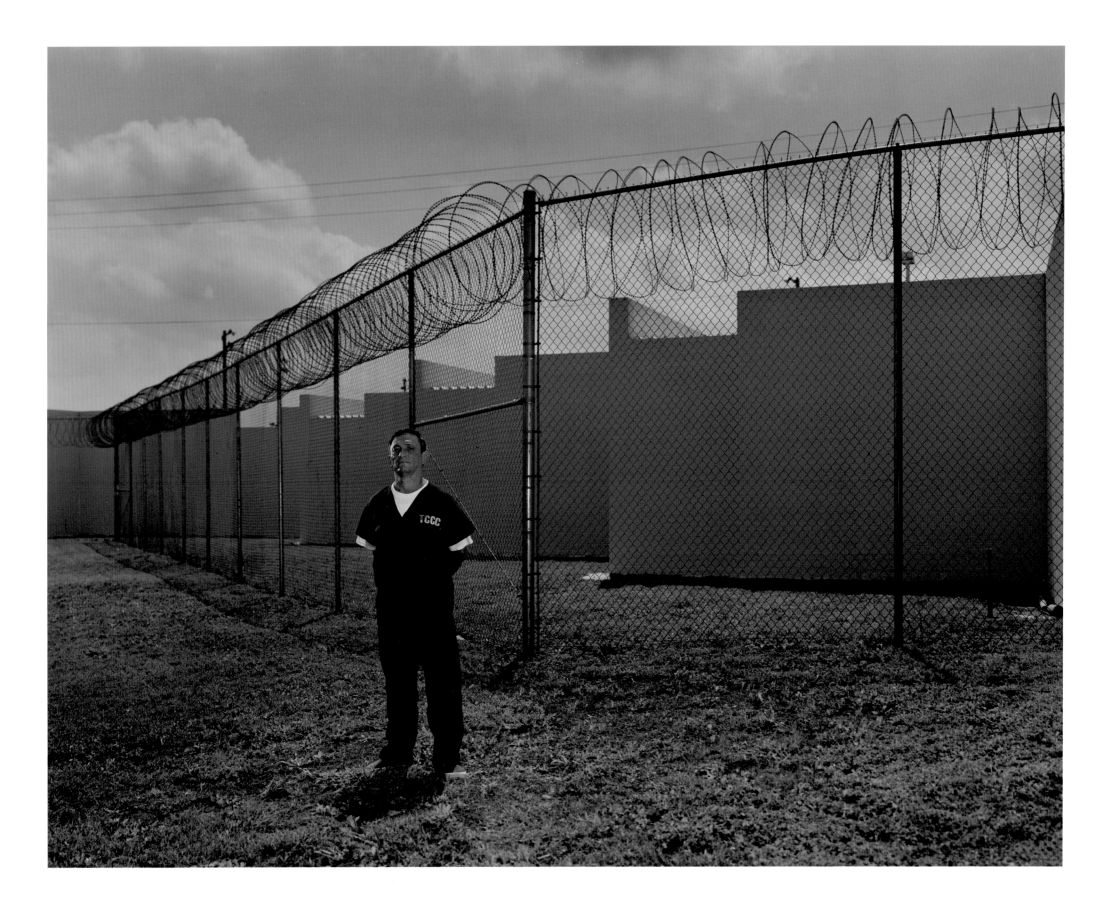

SAMUEL SCOTT and DOUGLAS ECHOLS
Scott's House, Savannah, Georgia
Scott was photographed under house arrest following his release on parole
Scott (left) served 15 years of a life sentence
Echols (right) served 5 of a 5-year sentence

In February 1986, in Savannah, Georgia, a woman was abducted by three men after leaving a bar. She was taken to a house by two of her assailants, where she was held down by one, and raped by the other. The victim fled to a nearby house and contacted the police. She led them back to the scene of the crime—Samuel Scott's house. Scott and Echols were there when the police arrived. Later the victim identified Scott from a photographic array, and Scott and Echols were taken into custody. At their trial, they claimed that at the time of the crime they were involved in a threesome with a married woman. The married woman testified on their behalf, but Scott and Echols were still convicted of rape, kidnapping, and robbery in March 1987. Both men continued to maintain their innocence. Fifteen years after conviction, they gained access to the biological evidence collected from the victim. DNA testing excluded both Scott and Echols. For months after the test results were known, Scott and Echols, who had already been released on parole as sex offenders, had to litigate as the prosecution adopted new theories of the case. These series included a scenario where Scott did not ejaculate and the semen came from prior consensual sex between the victim and another man. That man was eliminated through further testing. At one point, Scott's parole was violated because he couldn't afford to pay for an electronic-tracking bracelet that the state required him to wear. Finally, their convictions were vacated by judicial decision in July 2002. The prosecution declined to retry them in October 2002.

"I'd like to add that first of all, we are innocent. And second, they was giving me the opportunity to send an innocent man to prison. They told me I had the opportunity to turn state's evidence against my co-defendant (Sammy). I told them that he didn't commit the crime because I was with him all the time. Then, the state told me that if I don't turn state's evidence against Sammy, that I was going to have to ride the bus with him. So I told the state, sixteen years ago, that they could go ahead and crank the bus up because my friend is innocent. And I been riding with him ever since." *–Douglas Echols*

"Once I was paroled I had to go and register as a sex offender which was the most horrific thing I ever had to do in my life. To actually go and get in front of a camera and have these people take pictures. And it's on computer now. Somebody wants to look on a computer and see who's a sex offender, what neighborhood is he in—and 'Sammy Scott' jumps up. It hurts. You can't find employment. I'm on parole. I am. And I have to pay $63 a week, every Thursday. I'm up on house arrest now. I can't leave 100 yards from where we sit. If I do, the beeper will go off and I'm certain to be arrested again. I don't understand why it's taking so long for Douglas and I to be exonerated when the scientific evidence clearly proved that we did not commit the crime. I mean, I understand this is Georgia, but the D.A. used the term— she said 'justice'. I'm trying to determine, where is the justice? Look at this state: Georgia … it's like we're stuck in time." *–Samuel Scott*

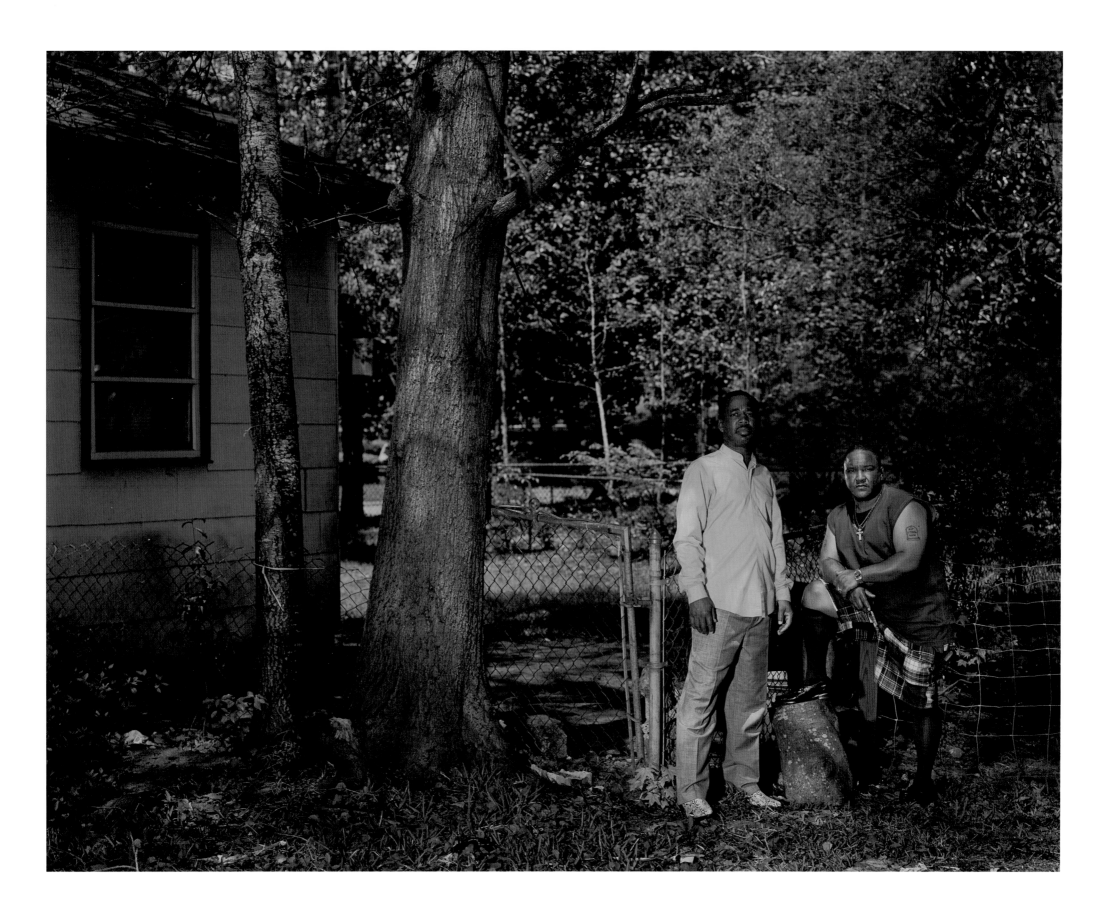

BRIAN PISZCZEK

The House of Bob, Akron, Ohio
Where Alcoholics Anonymous began
Served 4 years of a 15-to-25-year sentence

In July 1990, a woman in Cuyahoga County, Ohio was raped, assaulted, and robbed after answering a knock at her door. The perpetrator claimed to be a friend when the victim answered the door; then he attacked her with a knife, cutting her several times before raping her. Two months after the attack, the victim identified Brian Piszczek as the perpetrator from a photographic array and then in court. Piszczek, in his defense, offered an alibi that was corroborated by his girlfriend. He testified that he had been in the victim's house before, but only as an acquaintance and accompanied by a mutual friend. Nevertheless, Piszczek was convicted of rape, felonious assault, and burglary in 1991. Three years later, Piszczek gained access to the biological evidence, which included vaginal swabs and samples from the victim's nightgown. DNA testing proved that Piszczek could not have been the perpetrator, and his conviction was overturned in October 1994.

"I told my father one time, 'The pains and struggles that I'm going through out here ain't no different from the pains and struggles when I was in prison.' It was like I was still in a prison. I don't know how to put that—I'm not a psychiatrist, but I just wasn't free about something. A past you could not shut the door on. And then you have to live with yourself day to day, trying to survive, trying to make it in life, trying to do the right thing…. And I think psychologically there was some complications there that contributed to my addictions. That's how I dealt with my pains. That's how I dealt with my fears. That's how I dealt with my loneliness. That's how I dealt with my anger. That's how I dealt with my sadness…. I'm not going to survive any more if I keep going on with my addictions. I have to continue forth with recovery at all costs. Just like I pursued my freedom." *—Brian Piszczek*

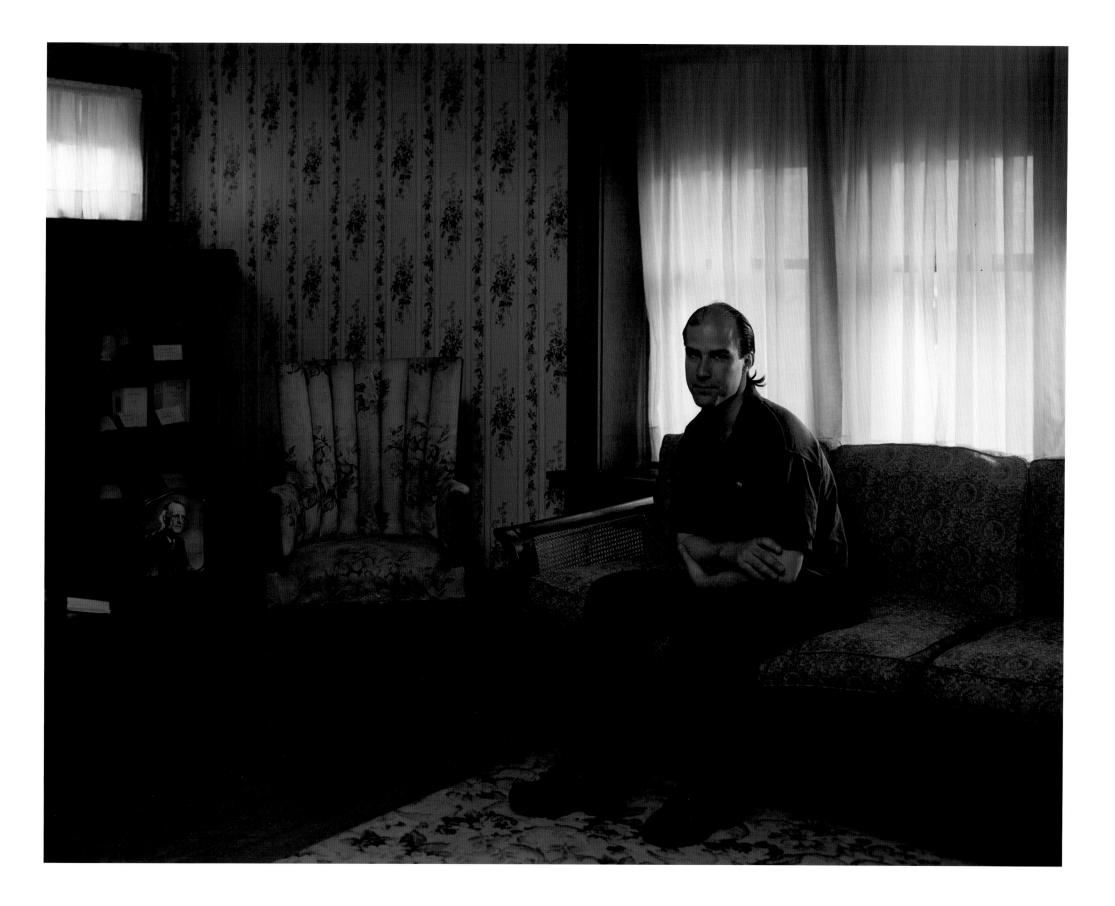

CALVIN JOHNSON

Scene of the crime, Yorktowne Court, Jonesboro, Georgia
With father and advocate, Calvin Johnson, Sr.
Served 16 years of a life sentence

In March 1983, in Clayton County, a predominantly white suburb of Atlanta, a woman was choked with a belt, raped, sodomized, and robbed in her home. This crime was similar to another rape that had occurred in neighboring Fulton County two nights earlier. Based on the victims' cross-racial identifications, Calvin Johnson was charged with both crimes. He was convicted of rape, aggravated sodomy, and burglary in the Clayton County case, and acquitted of all charges a few months later in the Fulton County case. Both victims testified at both trials. One of the victims identified him in a photographic array but not in a lineup, while the other victim identified Johnson in a lineup but not in a photographic array. Other evidence included clothing similar to the assailant's found in Johnson's house and semen found on vaginal swabs. In the case for which he was convicted, an African-American pubic hair that did not come from Johnson was found on the victim's bedding, and the victim testified to never having had black guests. The prosecution discounted this evidence, suggesting that it may have come from the laundromat. The evidence presented was almost identical in both trials. The only distinction between the two was that the Clayton County jury that convicted him was all white and the Fulton County jury was comprised of seven blacks and five whites. Sixteen years later, DNA testing on the Clayton County rape kit exonerated Calvin Johnson. He was freed in June 1999.

"My dad, he's a little harder than I am. It was hard for him, because he recognized it. He could see what was happening. He was brought up in a different era than I was. He's seen a lot of prejudices. He's seen a lot of times when people have been railroaded— when blacks have been unjustly accused, abused and mistreated…. He's seen that, he's lived it. He's lived through it. He's protested it. He's been on marches. He's been in the Civil Rights Movement. So when this was happening he recognized it, and he looked at it, and he knew in his heart that his son didn't have a chance. They were going to railroad me. And it hurt him to watch that and not be able to do anything about it. He tried to do what he could, but there was only so much." *–Calvin Johnson*

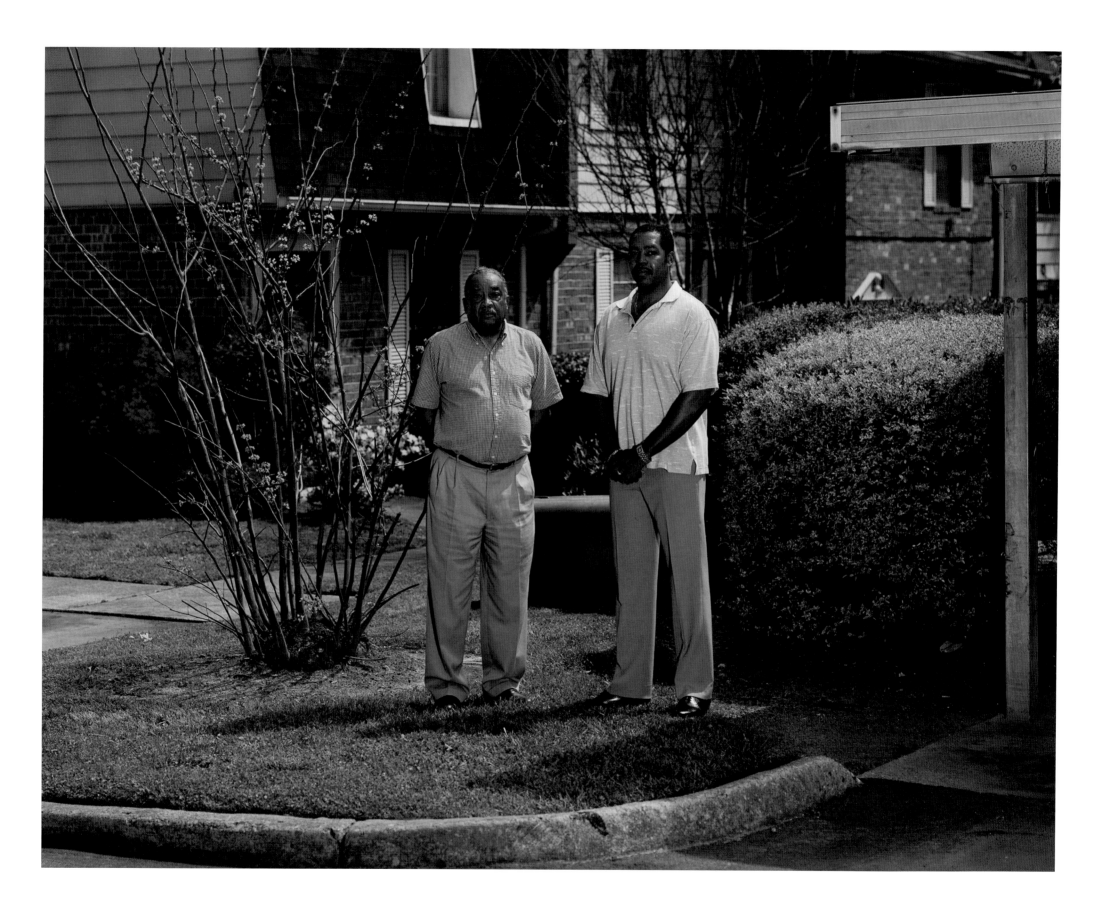

LARRY MAYES
Scene of arrest, The Royal Inn, Gary, Indiana
Police found Mayes hiding beneath a mattress in this room
Served 18.5 years of an 80-year sentence

In October 1980, two assailants entered a gas station in Hammond, Indiana, threatened the clerk with a gun, demanded money, and then forced her to leave with them. The victim was beaten with the gun and raped by both assailants before being released. Based on her description and identification, Larry Mayes was convicted of rape, robbery, and unlawful deviate conduct in 1982. According to the description, one of the perpetrators was much taller and heavier than the other. Although they both raped her, only the smaller perpetrator ejaculated. The victim identified Mayes as the smaller assailant in a photographic array, but only after failing to identify him in two live lineup procedures. At some point in this process, without the knowledge of prosecutors or defense lawyers, the victim was hypnotized. None of the fingerprints collected from the scene belonged to Mayes. Serological testing was performed on semen found on the vaginal swabs and underwear collected from the victim, but the results were not useful for identification. After conviction, Mayes fought to obtain access to the biological evidence for DNA testing. For years, the evidence was said to be lost. In August 2000, however, a court clerk was able to confirm that the rape kit still existed and was in the court's possession. DNA testing in 2001 conclusively established that Larry Mayes was innocent, as he had claimed since his arrest. He was exonerated and freed in December 2001.

"Why? Because I'm young, gifted and black. It's always been that way. Even before you was born. I was there. I know. What it really is, is genocide: getting rid of all the young black men so we can't produce. Put 'em all in the penitentiary. There's so many guys in there that are innocent but can't get a chance. They take us, put us in cages, and leave us there. You go there. The whole cell house is nothing but black dudes. It'll always be that way." *–Larry Mayes*

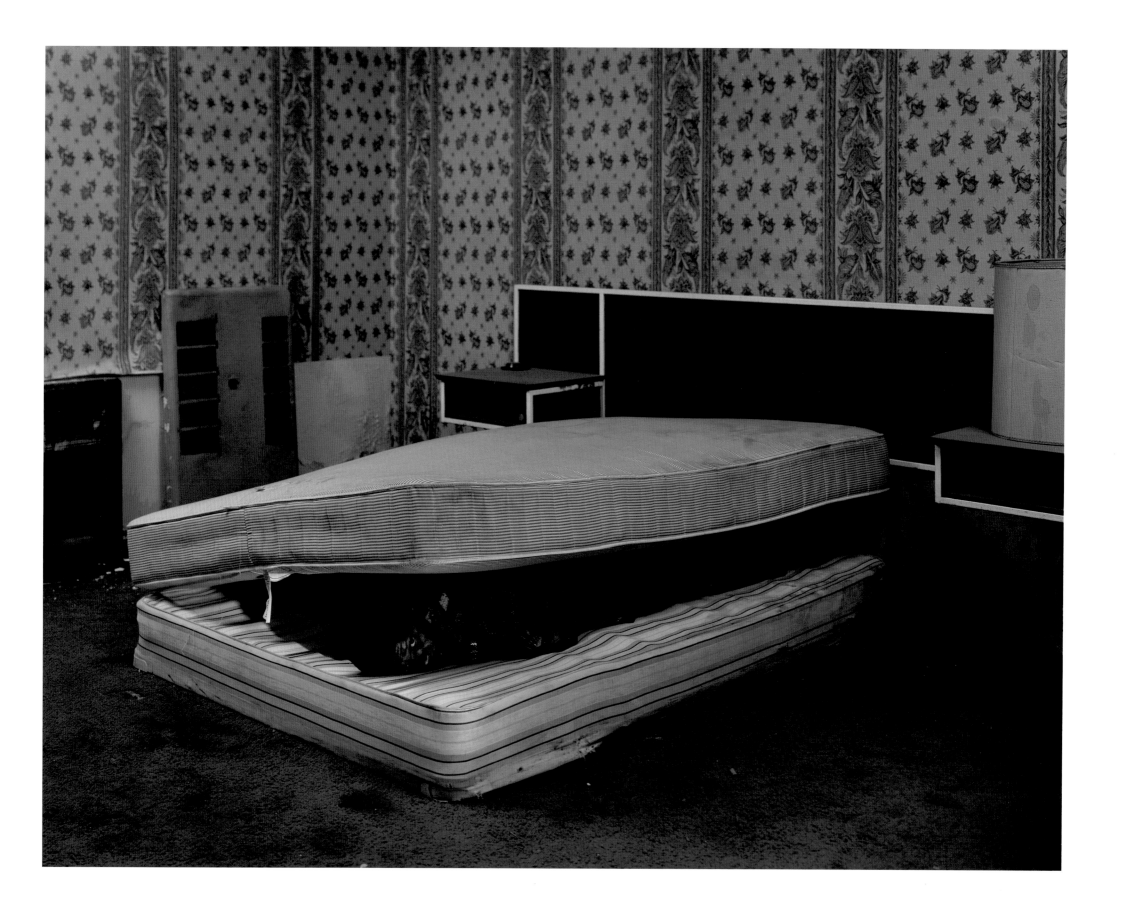

DAVID SHEPARD
Outside Newark Airport, Newark, New Jersey
Served 10 years of a 30-year sentence

In 1983, a woman was abducted from a parking lot in the Newark, New Jersey area. Two assailants forced her into the back seat of her car, drove her to a residential area, and then raped her. Some of the items stolen from the victim were found outside of Newark Airport where David Shepard worked. The victim, accompanied by two detectives, observed and listened to airport employees as they received their paychecks in a hangar on New Year's Eve. The victim identified Shepard, and he was the only man arrested for the crime. Based on the victim's eye and voice identifications, and conventional serology testing that failed to exclude him, Shepard was convicted of rape, robbery, weapons violations, and terrorist threats in 1984. In 1992, Shepard filed for access to the biological evidence for DNA testing. The first tests excluded him as a contributor of the sperm on the vaginal swab, but only one profile was found. Because there were two perpetrators, Shepard could not be ruled out. A second round of tests revealed a second profile, which could not be fully analyzed. A final round of DNA testing on the victim's underwear produced two profiles that excluded both Shepard and the victim's boyfriend. Based on these results, Shepard was exonerated and released in May 1994.

"The first time my mother ever came up to see me I refused to see her. They put me on what they call a suicide watch because I refused. She came twice. On the third time, they made me see her because she put on such a ruckus downstairs. I told her I didn't want to see her. And my son? It took me almost three years before I allowed him to come. I didn't belong there, so they didn't belong there.... When I was away, I shut myself down in regard to my feelings and the people I cared about. I isolated myself from them. I kept everybody at a distance.... When you're locked up for so long you get hard. You don't think of nobody but yourself. You only think of what you have to do to survive the next day. All the things you're taught as a child, be nice, be courteous, and all this other stuff—you lose all that, you leave it alone, because there's no place for it. There's no place for me caring about you and you caring about me. That's not the place for it. When I came home, I wasn't the same person I was when I left." *–David Shepard*

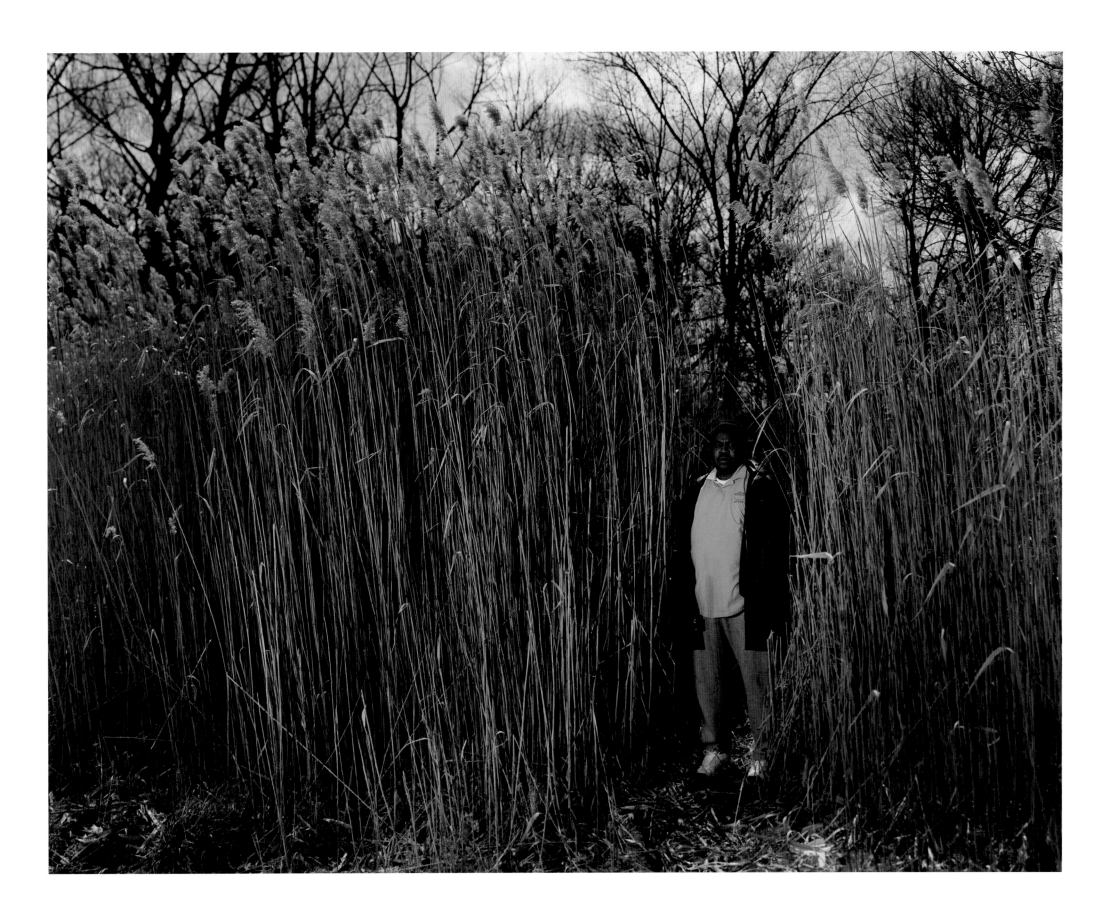

JEFFREY PIERCE
Lake Huron, Port Huron, Michigan
Served 15 years of a 65-year sentence

In May 1985, a woman entering her Oklahoma City apartment was accosted, raped, and sodomized by an intruder. Though her initial description of the perpetrator did not match him, Jeffrey Pierce became the focus of the police investigation. Shortly after the crime, Pierce had been pointed out to the victim as a possible suspect because he was part of the landscaping crew doing work around her apartment complex. The victim did not identify Pierce. Months later, the police showed the victim a photo array that contained a picture of Pierce in a tan shirt, similar to the shirt the victim described as being worn by the perpetrator. She picked out Pierce. He was convicted of rape and robbery in 1986 based on the victim's identification and the laboratory work of Joyce Gilchrist, then a well-known forensic analyst at the Oklahoma City Police Laboratory. Gilchrist claimed that head and pubic hairs found inside the victim's apartment matched Pierce. When a whistle blower within the Oklahoma City Police Laboratory raised questions about Gilchrist's work, Pierce's case became a focal point of investigation. DNA testing of semen and reexamination of the hairs excluded Pierce and inculpated another man already in jail for rape and robbery. Pierce was exonerated and released in May 2001, to be reunited with his wife and children from whom he had been separated for fifteen years. Joyce Gilchrist was fired, and thousands of her cases are now being reviewed.

"I was up for parole three times and was denied all three times. They came in with a sex offender program. They told me to sign up for it. I refused. They said that I'd lose all my privileges. I still refused to go to it. You have to admit that you are guilty to even get into the thing and there's was no way I would ever admit I was guilty. They took my TV, my radio, my canteen privileges, my phone privileges. I had one hour of visits a week with immediate family members behind glass—I couldn't even touch them. I really had nothing…. But I couldn't go up there and lie. I'd just be lying. I knew I was innocent. If that's the way I died—I knew, my family knew, and all my friends knew that I was innocent." *–Jeffrey Pierce*

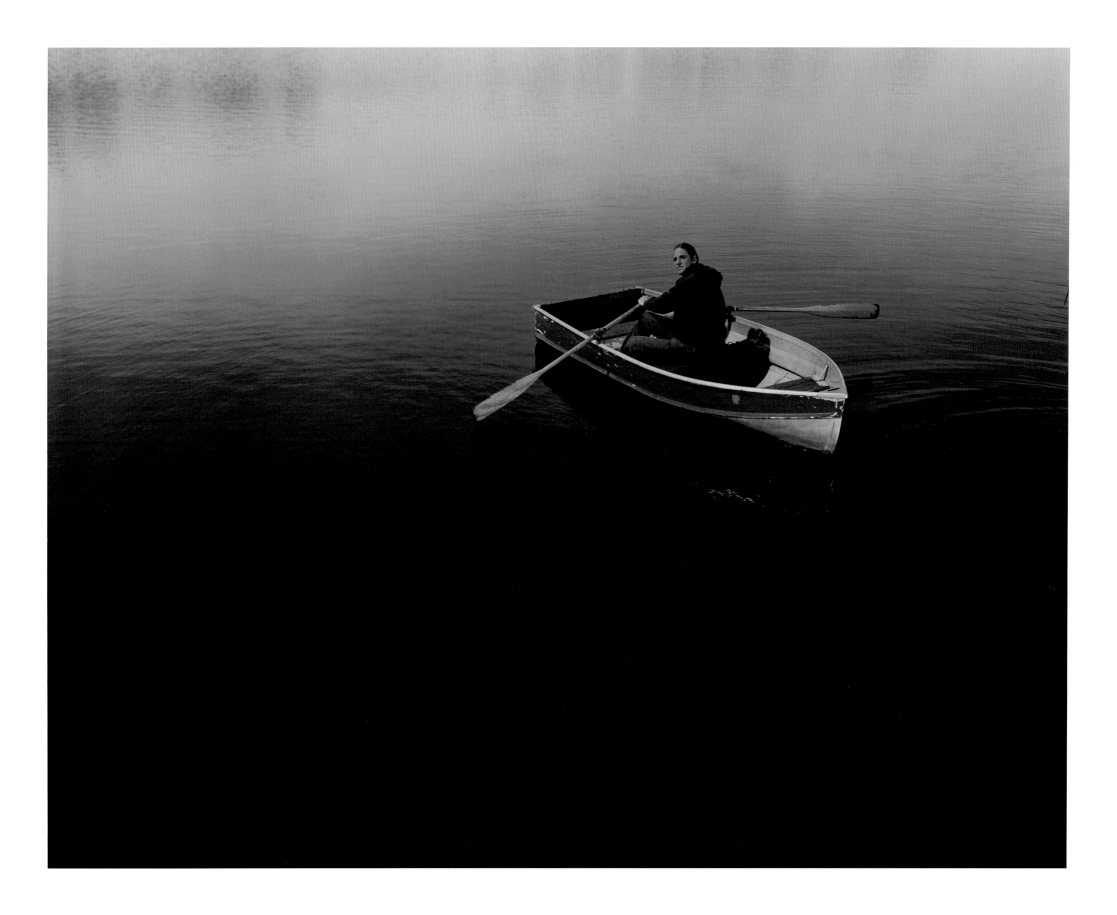

WALTER (TONY) SNYDER

Alibi location, Snyder's living room, Alexandria, Virginia
The scene of the crime, across the street, is reflected in the mirror
Served 7 years of a 45-year sentence

In 1985, in Alexandria, Virginia, a white woman was attacked in her home. The perpetrator broke down her door, raped, and robbed her in the middle of the night. The police photographed several young black men in the community and displayed the photos to the victim, who was unable to make a positive I.D.. Shortly after she reviewed the photos, she returned home, looked out her window, and saw Walter Snyder across the street washing his father's car in the driveway. Snyder's photo was among the group she had just viewed at the police station without success. Seeing the familiar face precipitated a call to the police proclaiming that the assailant was Snyder. To seal the identification, the police staged a one-on-one showup and further claimed that Snyder had confessed to the police. A search of his family's home found red athletic shorts similar to those worn by the assailant. Conventional serology failed to exclude him as the source of the semen. At his 1986 trial, the jury rejected the alibi testimony of his mother that he was home in bed, and convicted Snyder. In 1992, DNA testing on the sperm recovered from the rape kit excluded him. His petition for a full gubernatorial pardon, supported by the prosecutor and the trial judge, was granted in April 1993.

"I got forty-five years for living fifty-seven feet across the street from the victim. And I don't know what else to tell you. I don't think they did a serious investigation. They just thought they had someone who lived across the street that fit the description: the weight, the height, the build…. The investigation went on for a couple of months. I knew that I hadn't done anything. So I went to the police station one day and asked if I could get my stuff back since it had been three months. I had a boxing tournament coming up in Texas and they had my uniform, my cup, my headgear. They had me sit in the lobby. They called the victim and told her they had someone for her to look at. When they came back in the room they said, 'You're under arrest. We're charging you with rape.' I went ballistic. They handcuffed me and took me to jail. I didn't see the world until six years and ten months later…. One thing that I really regret is being incarcerated in '86 when I had a chance to make the Olympic boxing team in 1988. My idols then were Sugar Ray Leonard and Marvin Haglar, Roberto Duran, Wilfred Benitez, Alexis Arguello. That was something I really wanted to do—fight, box, slug it out in a square circle. But Roy Jones and Oscar de la Hoya, those were the ones I watched from my prison cell win the medals in the Olympics. That was a beautiful Olympics, too. That's the one—my age and youth—I had a good shot at it." *—Tony Snyder*

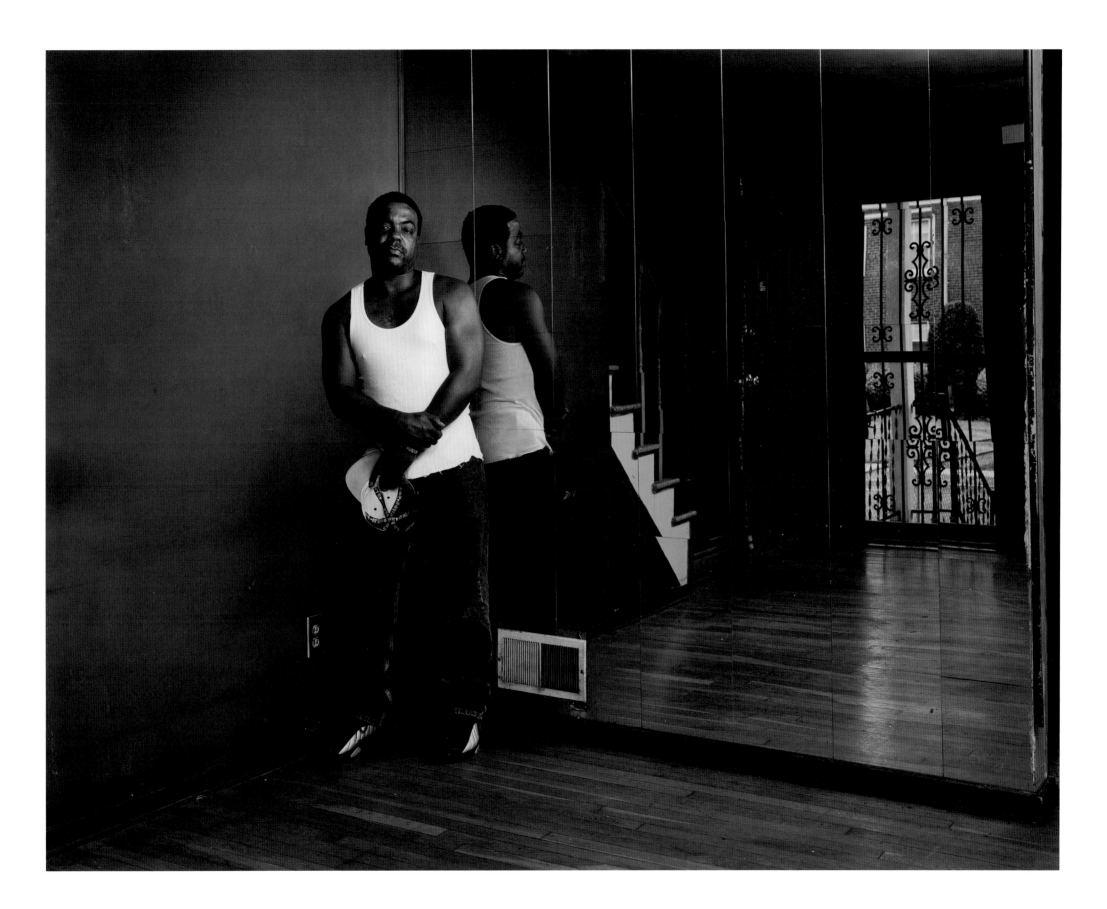

WALTER SMITH
Innis Park, Columbus, Ohio
Served 12 years of a 190-year sentence

In July 1984, Walter Smith, then eighteen years old, was arrested for attempting to rob a gas station. While he awaited trial, Smith was implicated in three sexual assaults that had occurred years earlier in the Columbus, Ohio, area. All three victims identified him. Smith entered a guilty plea for the attempted robbery charge but asserted his innocence of all three rapes. Based solely on eyewitness testimony, Smith was convicted of two of the three rapes in 1986. He began to request DNA testing in 1987, but would not see results until 1996. DNA test results excluded him as a contributor of the biological evidence left by the assailant in both rape cases. Replicate testing demanded and performed by the prosecution confirmed these exculpatory results. Smith was cleared of the rape charges and granted parole for the robbery charge in 1996. Smith is now a professional body builder and motivational speaker.

"I was a body builder before I went to prison. So the first thing I did on the inside was I got back into weight training. My first workout in prison was April 26, 1986. My last workout in prison was November 24, 1996. That was all part of the plan.... The judge, being sarcastic, told me to carry my behind to the penitentiary and take good care of myself. He was trying to be funny but he planted the seed—take care of yourself. Take care of yourself. And I will.... I've educated myself. I know the law—know it inside out. I know how long an officer has a right to keep me. I know how long it is before he's violated my Fourth Amendment right against illegal seizure. I understand what's the protocol for them to search me, to search my car. I know the seven exceptions to the search warrant. More importantly, I don't put myself in the situation. I command respect out here. I'm going to get mine. If you come at me, come right. Because if you're wrong, I'm going to get you." *–Walter Smith*

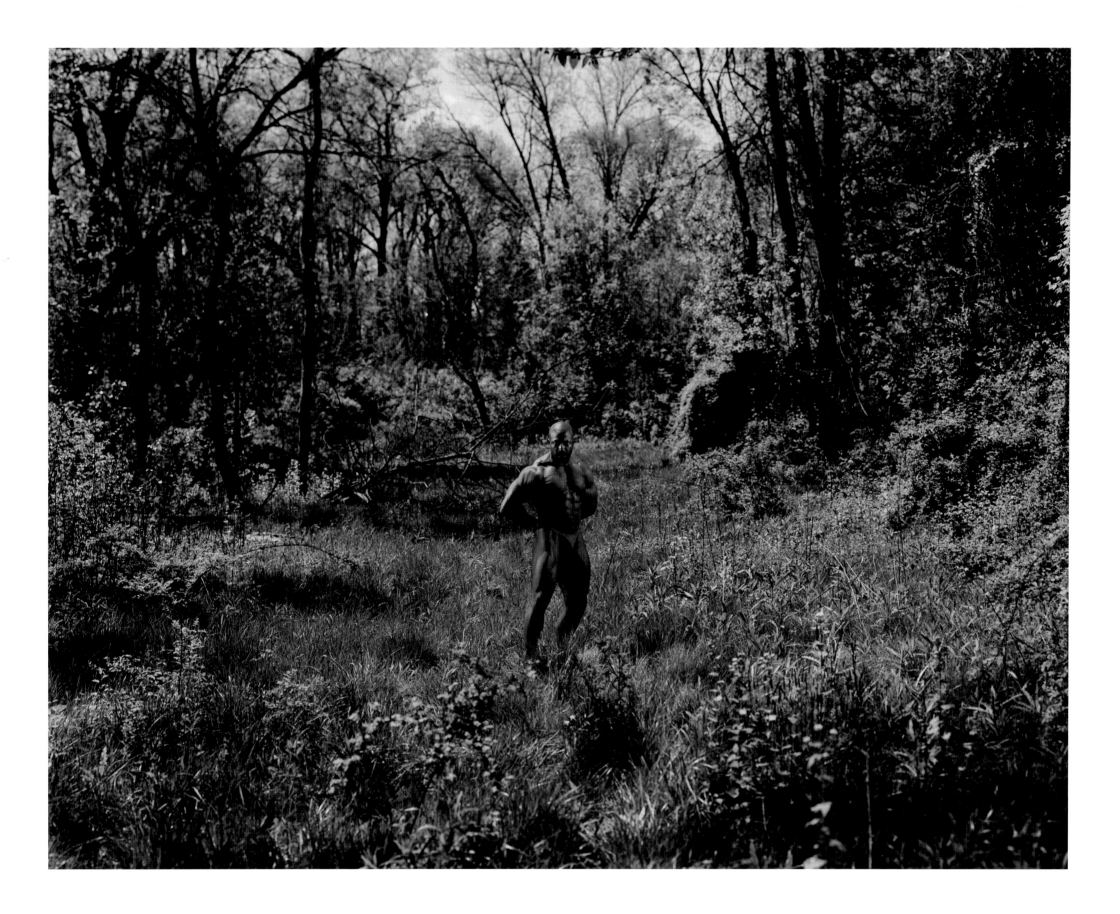

JAMES O'DONNELL
Scene of the crime, Cloves Lake Park, Staten Island, New York
With police sketch of the perpetrator
Served 2 years of a 3.5-to-7-year sentence

In 1997, a woman was attacked by a man in a park on Staten Island, New York. The lone assailant threw her to the ground and choked her. The victim fought back, scratching his face in an effort to push him away. He bit her hand before she passed out. The man fled before completing a sexual act. Police arrived and ultimately swabbed the bite mark and collected small pieces of human tissue from beneath her fingernails. When the description she gave to the police was published in a local newspaper, a reader called the police and claimed that James O'Donnell fit the description and was known to frequent the same park. Meanwhile, with the victim's cooperation, a composite sketch was prepared that looked nothing like O'Donnell. An old arrest photo of O'Donnell was shown to the victim and to another woman who had observed a "strange" man leaving the path and walking up a hill shortly after the attack. Following their cross-racial, positive photo identifications, O'Donnell was arrested, placed in a lineup, and again identified. Because there had been no completed sexual act, the prosecutor never requested DNA testing. At trial in 1998, O'Donnell and his wife (then girlfriend) testified that he was at home with the family the morning of the attack. Nevertheless, the alibi was overcome by the certainty of the victim and witness identifications. O'Donnell was convicted of attempted sodomy and second-degree assault. O'Donnell's appellate lawyer later discovered the rape kit with the bite mark swab and fingernail scrapings. DNA testing revealed an identical male profile for both the scrapings and the saliva from the bite. The DNA profile excluded O'Donnell. At first, the prosecutor attempted to invent a new theory of the case in which two men rather than one had attacked the victim. But as the victim claimed the perpetrator acted alone, O'Donnell was released in April 2000. Following replicate testing by the prosecutor's lab, the conviction was vacated and charges dismissed in December 2000.

"I couldn't believe my eyes when I saw the sketch.... I've had this Fu Man Chu mustache curving down my face all my life, since I was a kid. I've always had it.... They doctored me up to try to make me look like the sketch. When I was going into the lineup, the detective put my hair into a ponytail. My hair has never been in a ponytail.... Then they took a bowl of water. The detective took me by the wrist and he kept dabbing my hand in the water and slicking my hair back. Then he did it with the other hand: he slicked my hair back with the water. I didn't care because I was innocent. I figured, there's no way—no way—anyone could pick me out of a lineup. It's impossible. I was at home in bed with my wife and kid. This can't happen. And sure as shit, she picked me out of the lineup. I was amazed. I couldn't believe it. I started screaming, 'How can this be? I was home in bed with my wife. Go ask my wife and kid.' And nothing mattered. Nothing mattered.... I kept saying to my lawyer, 'Doesn't the truth have to come out?' And he'd say, 'Nope, the truth don't have to come out.' But the truth is all coming out now. It's pretty wild." –*James O'Donnell*

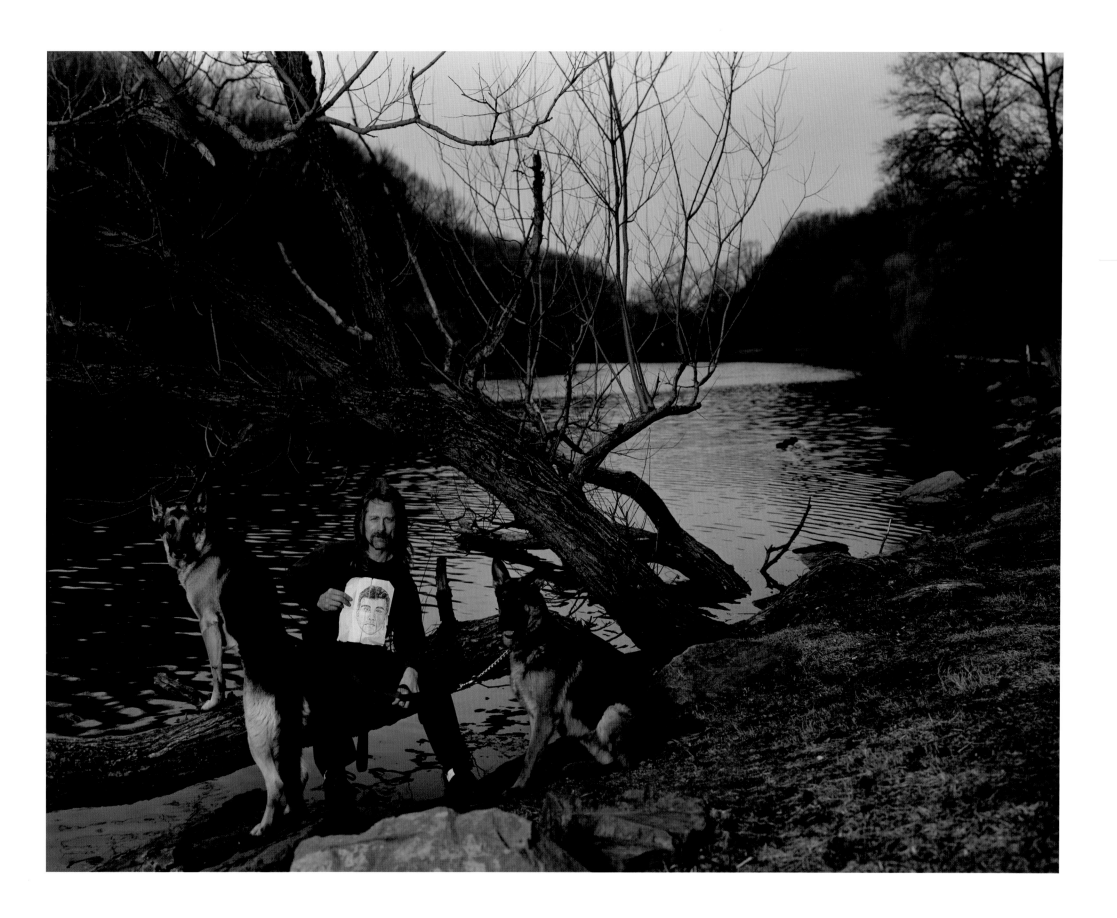

LARRY YOUNGBLOOD

Alibi location, Tucson, Arizona
With Alice Laitner, Youngblood's girlfriend and alibi witness at trial
Served 8 years of a 10.5-year sentence

In 1983, a ten-year-old boy attending a church carnival in Tucson, Arizona, was abducted and repeatedly sodomized by a perpetrator described as a middle-aged black man with a disfigured eye. The boy later identified Larry Youngblood as his assailant. At Youngblood's 1985 trial, the defense requested serological testing on the semen stains found on the boy's clothing. But, because the police had improperly stored the clothing, the biological evidence had degraded so that it was no longer suitable for conventional testing. An all-white jury convicted Youngblood of child molestation, sexual assault, and kidnapping, based mainly on the victim's cross-racial identification. The Arizona Supreme Court vacated the conviction, finding that the failure to preserve potentially exculpatory evidence violated Youngblood's due-process rights. In 1988, however, the United States Supreme Court reversed the decision, ruling that, in the absence of bad faith on the part of the police, there had been no due-process violation. The Supreme Court precedent established by this case constructed an almost impossible bar for those who would seek to prove innocence, as it relieved police and prosecutors of their duty to preserve possibly exculpatory evidence. Over the years, Youngblood maintained his innocence. He hoped that biological evidence that was too degraded for conventional testing could nevertheless be analyzed by DNA. In 2000, as a pre-condition to DNA testing, the police forced Youngblood to sign an agreement giving up his right to sue the police. DNA tests excluded Youngblood as the assailant, and he was exonerated in August 2000. In 2001, the profile was entered into a national felon database; it inculpated a man blind in one eye, and serving time in Texas on other charges.

"People look down at you as a child molester. That's about the most pitiful thing you can do to a person. That's a cold thing to say about somebody who's not really like that. Messing with a kid—that's unheard of. That's about the worst crime you could ever commit. And to live with it and be able to face people? And to be put on the stand knowing that you didn't do it? That's more horrible than you can ever explain. Crying's not going to make it go away. It's always, constantly with me.… I don't go around people. I don't look at kids. It's a sad thing to say, but I don't trust 'em at all. I don't even look at them or go around them for anything, anything at all.… Hell is here, heaven is when you die—you don't have to deal with society. This is hell, being here on earth. This is the hellhole. What they did to me— that's a cold thing. It's like sticking points in someone's heart, just leaving them there and then taking them out: they can stitch 'em up and tell you you'll be okay, but it's never going to be the same. Those are years lost. You can't get them back." *–Larry Youngblood*

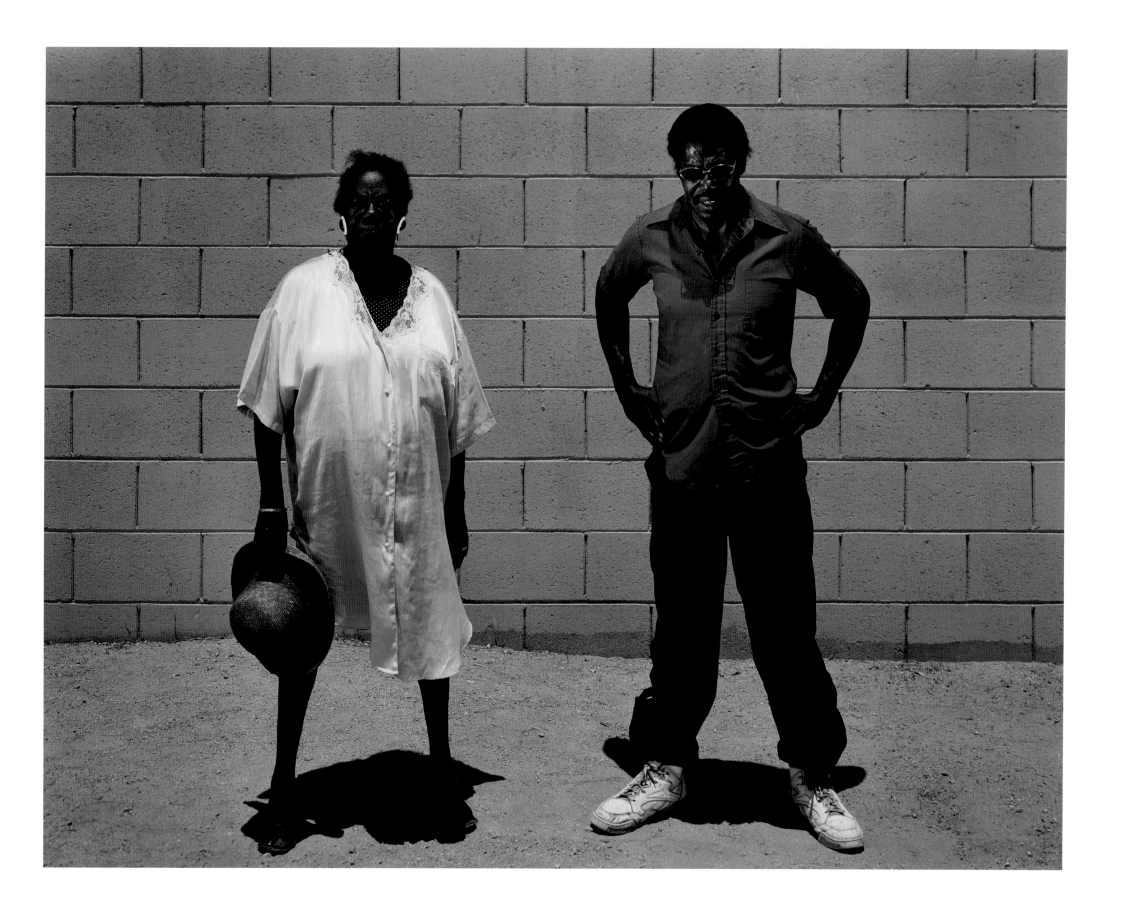

RON WILLIAMSON

Baseball field, Norman, Oklahoma
Williamson had been drafted by the Oakland Athletics before being sentenced to death
Served 11 years of a death sentence

In 1982, a young woman employed as a barmaid at the Coachlight Club in Ada, Oklahoma left work late one evening and was found dead the next morning, raped and strangled. Six years later, Ron Williamson, a former minor league baseball player in the Kansas City Royals system, and his friend Dennis Fritz were arrested and convicted of the crime. Williamson, who suffered from mental illness, was convicted on the testimony of jailhouse snitches, a confession that he had had a dream about the crime, and microscopic hair comparisons linking him and Fritz to seventeen head and pubic hairs found on and under the body. Glenn Gore, the star witness for the prosecution, said Williamson was in the Coachlight bothering the barmaid on the night of the murder. Twenty-three other people in the Coachlight, many of whom had known Williamson for years, had not seen him. Williamson was represented by a blind lawyer who lacked adequate assistance and did nothing about the fact that his client was actively psychotic at the time of the trial. Williamson came within five days of execution. He spent much of his time on death row without proper medication, screaming that he was innocent and banging his head against the cell door. After his conviction was vacated by a federal court on the grounds that his lawyer was ineffective, DNA testing was performed in 1999 demonstrating that neither Fritz nor Williamson was the source of the seventeen head and pubic hairs found on the victim or the semen recovered from inside her. On April 22, 1999, Williamson was released from the same courthouse where he had been convicted. On that day, after it was disclosed that DNA results from the semen matched Glenn Gore, Gore escaped from a work-release program where he was serving time. Glenn Gore was eventually captured and has been charged with the woman's murder.

"I hope I go to neither heaven nor hell. I wish that at the time of my death that I could go to sleep and never wake up and never have a bad dream. Eternal rest, like you've seen on some tombstones, that's what I hope for. Because I don't want to go through the Judgment. I don't want anybody judging me again.... I asked myself what was the reason for my birth when I was on death row, if I was going to have to go through all that. What was even the reason for my birth? I almost cursed my mother and dad—it was so bad—for putting me on this earth. If I had it all to do over again, I wouldn't be born." *–Ron Williamson*

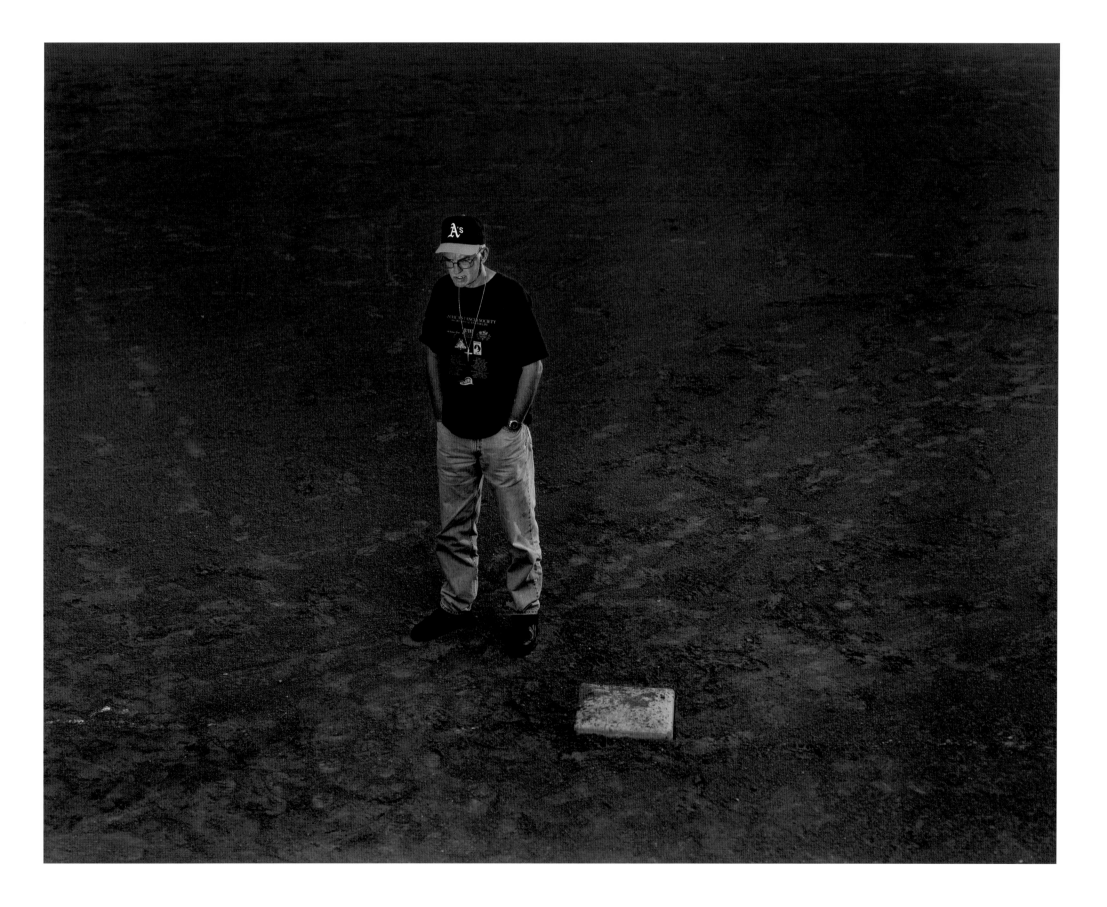

DENNIS FRITZ
Coachlight Club, Ada, Oklahoma, where victim worked and was last seen
With mother, Wanda, and daughter, Elizabeth, whom he did not see for 11 years
Served 11 years of a life sentence

In 1982, a young woman employed as a barmaid at the Coachlight Club in Ada, Oklahoma was found dead, raped and strangled. Six years later, Dennis Fritz, a high school science teacher, and his friend, Ron Williamson, were arrested and convicted of the crime. Fritz was convicted largely on the testimony of jailhouse snitches, who met him after his arrest. Microscopic hair comparisons linked him and Williamson to seventeen head and pubic hairs found on and under the body. Fritz and Williamson were friends who sometimes frequented bars together. Fritz sought DNA testing for close to a decade before it was finally performed in 1999. The tests showed that neither Fritz nor Williamson was the source of the seventeen hairs found on the victim or the semen inside her. On April 11, 1999, Dennis Fritz was released from the same county jail where the snitches had claimed he confessed and from the same courthouse where he had been convicted. That day, Dennis Fritz saw his daughter, Elizabeth, for the first time in eleven years. Although he wrote or spoke with her nearly every day, he had not permitted her to see him in prison. Also the same day, it was disclosed that DNA results from the semen matched Glenn Gore, the state's key witness in the trial. Gore escaped from a work-release program where he was serving time and has been charged with the woman's murder.

"The main thing that was really on my mind at that time was having to leave my family and be separated from them and everything that I knew. Elizabeth was twelve years old when I was convicted. Even though I was in a medium security prison, it still had its share of turmoil and violence in the visiting room. There were lots of lewd sexual acts going on and it was still pretty untamed. I sure didn't want her to see that. I didn't care for her to see her dad behind the eight-ball like that…. What's hard about prison life when you're innocent is that everyday another brick in the wall comes up. You slowly, unconsciously, blot out the past. You blot out your feelings and any emotions you have. They become too painful to deal with. I built the wall piece by piece. I had to get myself ready to do a life sentence…. After I got out, I had to take each brick down, brick by brick, and not let too much light in at one time. That was scary. Just as scary, if not more so, than actually having to go to the penitentiary." *–Dennis Fritz*

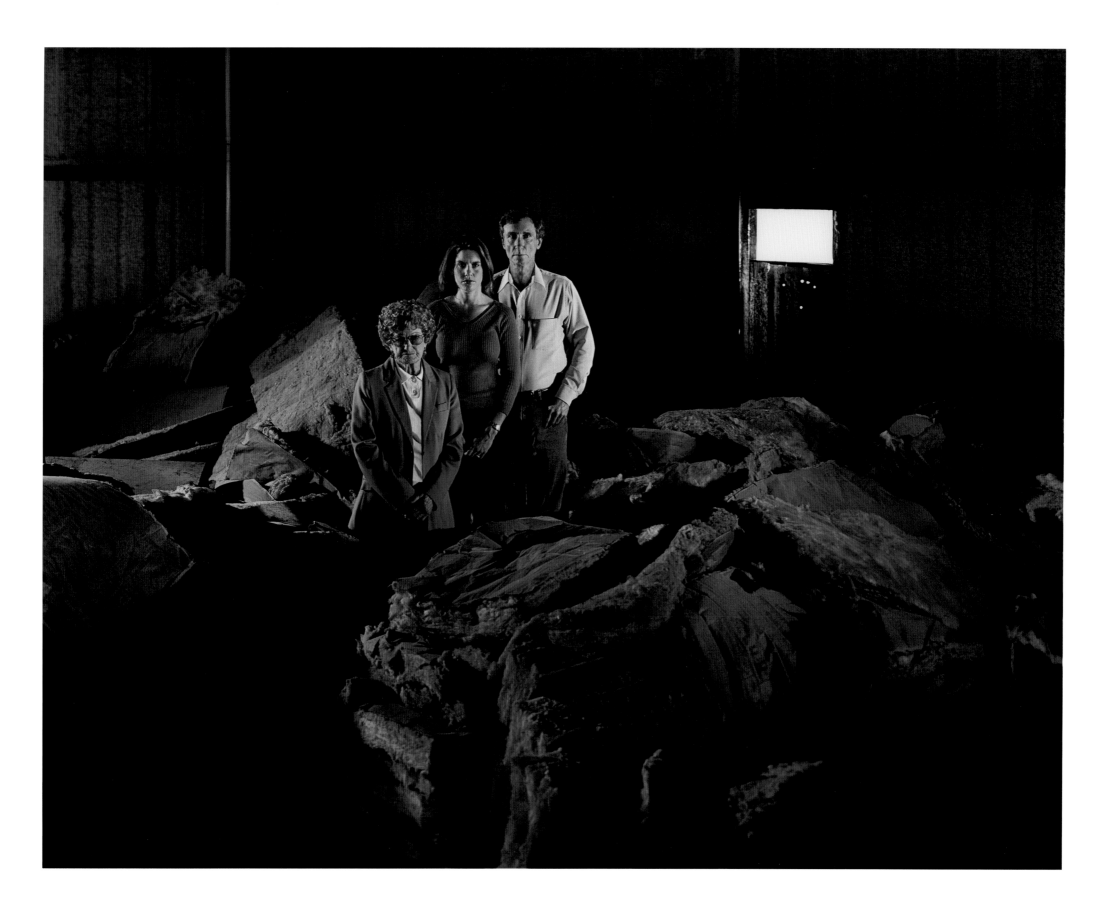

MARVIN ANDERSON

Hanover Courthouse, Hanover, Virginia
In the courtroom where Anderson was convicted
Served 15 years of a 210-year sentence

In July 1982, a young woman was brutally attacked and raped in Hanover, Virginia. The victim told the investigating officer that the black assailant claimed to "have a white girl." The officer knew of one black man in the small town who was living with a white woman—Marvin Anderson. Anderson, a recent high school graduate, had no prior record and hence no mugshot on file with the police. An officer went to Anderson's workplace, and obtained his employment ID card with color photo. The officer showed it to the victim, along with six other black-and-white mugshots. The victim picked Anderson's picture from the photographic array and later identified him in a live lineup. (Anderson was the only person in the lineup whose picture was also in the photographic array.) Based on the victim's identification, Anderson was convicted of rape, forcible sodomy, abduction, and robbery in March 1983. Five years later, a man named John Otis Lincoln came forward and confessed to the crime. The same judge who sentenced Anderson in 1982 now found Lincoln's confession incredible and upheld Anderson's conviction. Anderson tried for years to have the biological evidence from the rape kit tested, but he and his attorneys were repeatedly told that the evidence had been destroyed. By chance, they later learned, samples had been retained in a laboratory technician's notebook. In 2001, four years after Anderson had been paroled, DNA testing excluded him as the source of spermatozoa left by the perpetrator. The evidence had degraded and only a partial profile was obtained, but it was enough to exonerate Anderson and provide a partial match to the profile of John Otis Lincoln.

"I'm disappointed. Disappointed in the way the system is set up. Disappointed in the fact that there are still some states that refuse to accept DNA. They'll use DNA to convict a person but they refuse to accept DNA to free a person. Why? Because no one wants to admit mistakes, especially the law.... I believe in the law 100 percent, but I don't believe in the people who enforce the law. They're human and they do some dirty things.... I used to make myself look at the world as being total darkness and me the only person being in it. That's basically what being incarcerated is. You're away from the world, and the people that you love, and everything around you is just total darkness." –*Marvin Anderson*

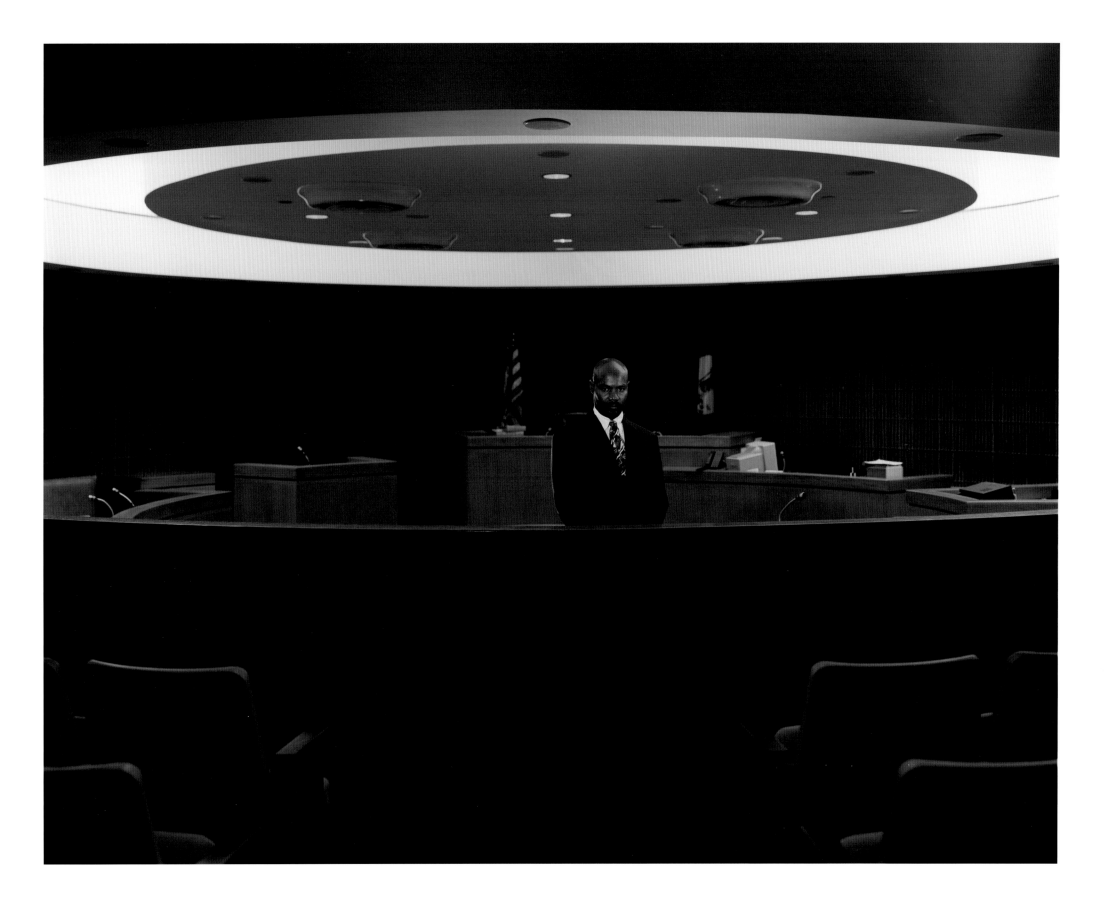

JOHN DIXON
Scene of the crime, Irvington, New Jersey
Served 10 years of a 45-year sentence

In December 1990, a young woman was abducted while walking in Irvington, New Jersey. She was raped at gunpoint and robbed after being dragged through an alley and a number of backyards. After the perpetrator fled, the victim went to a nearby home and contacted the police. She later identified John Dixon as her assailant from two separate photographic arrays. In July 1991, Dixon pled guilty to aggravated sexual assault, kidnapping, and unlawful possession of a weapon. He later asked the court to withdraw his guilty plea, claiming that he had been fearful of a much longer sentence if convicted by jury. He claimed to have been made to believe that he could not win his case. Dixon also requested DNA testing of the evidence collected from the victim shortly after the crime. Despite the prosecution's plan to use forensic evidence as proof against him, they claimed that DNA testing would not be relevant. The court denied Dixon's requests, and he was convicted in February 1992. Nine years later, Dixon secured DNA testing on the rape kit evidence, which excluded him as the source of the semen. The court vacated his conviction in November 2001, and Dixon was released that December.

"You figure this. First they accuse you of something so despicable and heinous, it's not even describable. I mean you think about it. My baby sister Patty died. She died because some man raped her and threw her from a thirteen-story building to her death. They think they're going to turn around and accuse me of some crap like that? The man said forty-five years. Forty-five years! My legs buckled, I almost passed out in the courtroom. Can you imagine forty-five years? Come on man—forty-five years. The average black guy on the streets ain't living to forty-five and they trying to give me forty-five years to do." *–John Dixon*

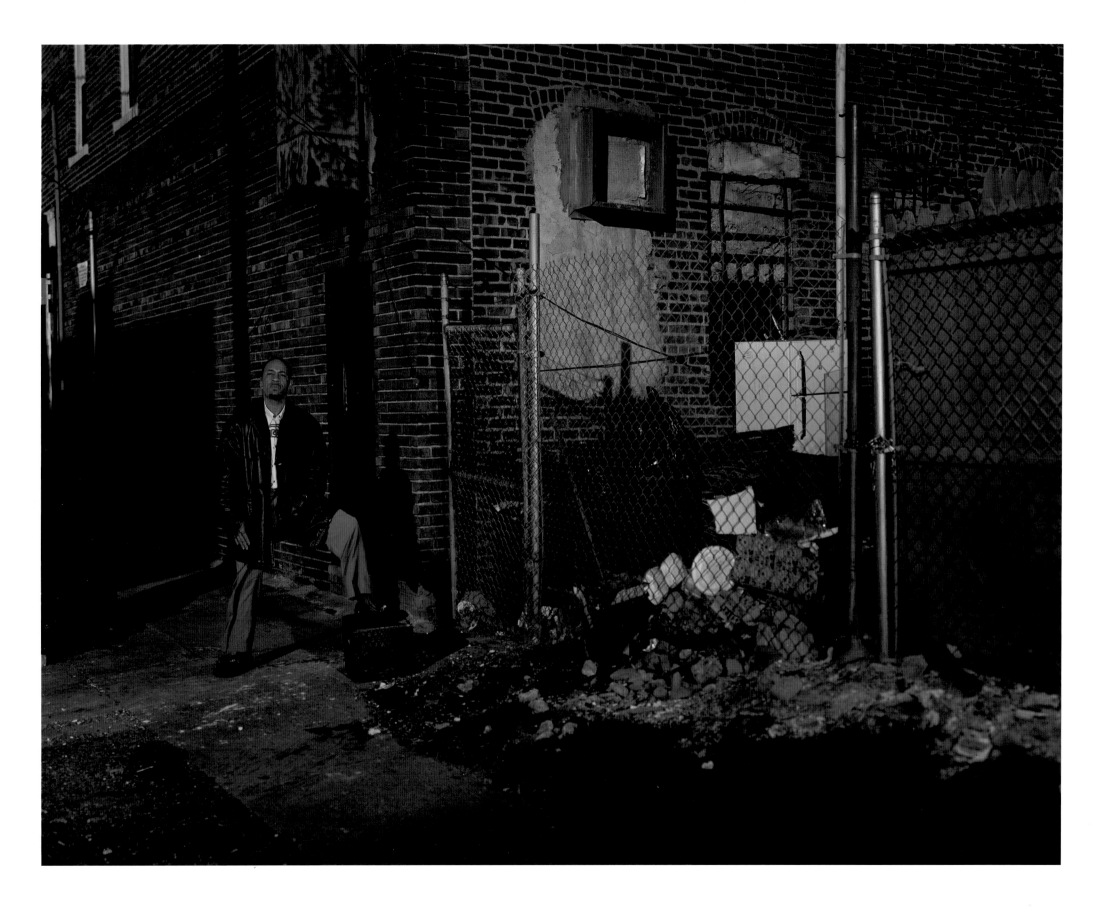

PAULA GRAY, DENNIS WILLIAMS, and VERNEAL JIMERSON

Scene of the crime, Ford Heights, Chicago
Three of the five defendants in the case known as the "Ford Height Four"
Gray (left) served 6 years of a 50-year sentence, Williams (middle) served 18 years of a death sentence, and Jimerson (right) served 11 years of a death sentence. Not shown here: Kenneth Adams served 18 years of a 75-year sentence, and Willie Rainge served 18 years of a life sentence

In 1978, a young white couple was abducted from a filling station and taken to an abandoned house in the Ford Heights section of Chicago. The young woman was raped repeatedly, and both victims were shot and killed. A man who lived nearby identified three young black men and a young black woman—Kenneth Adams, Willie Rainge, Dennis Williams, and Paula Gray—and placed them at the scene of the crime that night. Police questioned Gray, then seventeen years old, for two days. At grand jury proceedings, Gray testified that she witnessed the crime, and implicated yet another defendant, Verneal Jimerson, who was not tried until 1985. Gray recanted before trial and was charged along with Adams, Rainge, and Williams for the murders and for perjury. Based on the testimony of the eyewitness and a jailhouse snitch who claimed that he heard Rainge and Williams discussing the crime, all four defendants were convicted in 1979. Rainge and Williams won appeals in 1982. Prosecutors approached Gray, and she agreed to testify against the two men and Verneal Jimerson in exchange for her release. Based on her testimony and that of the original eyewitness, who now placed Jimerson at the scene as well, all three men were convicted. Williams and Jimerson were sent to death row. All four men continued to proclaim their innocence. In 1995, Jimerson's conviction was reversed, and prosecutors agreed to perform DNA testing on the evidence. Test results vindicated all four men. Law students investigating the case discovered a previously undisclosed police report indicating that another witness had come forward and identified four different men. Three of those men eventually confessed to the crime; the fourth had died. DNA testing corroborated their confessions. Gray's conviction was overturned in 2001, and she was pardoned in November 2002.

"They took away my family. I hurt so bad on the inside. I just don't trust no police. I got a gun pointed to my head. They took me to the scene of the crime. There was a lot of blood on the floor and I have not been right since then. I go home, I look under the bed, I look in my closet. What happened to us is wrong. I can't get this out of my mind. I feel like all the guys hate me for confessing. I don't want them to hate me. I love them. I just go through so much." *–Paula Gray*

"You took me out of society. You decided that you was going to make me a misfit, a good-for-nothing. I could have been a doctor, I could have been a lawyer, architect. I could have been a lot of things 'cause I got a whole hell of a lot of aspirations. I feel just like Bill Gates. I don't never quit thinking. I believe I can invent a whole lot of things. But how much time do I have left? If I could have got an early start maybe I'd have been sitting in some corporate conference with Bill Gates. We would have been talking about Microsoft. They didn't give me that opportunity." *–Dennis Williams*

"Go where we want to go, that's happiness, that's peace. I know I've been in hell. I'm in heaven now. The day I was released it seemed like the sun came down close to earth and just started shining. It was the happiest day of my life. I just stood outside under the sun. It was a beautiful day—went and ate me a hamburger and got me a Budweiser." *–Verneal Jimerson*

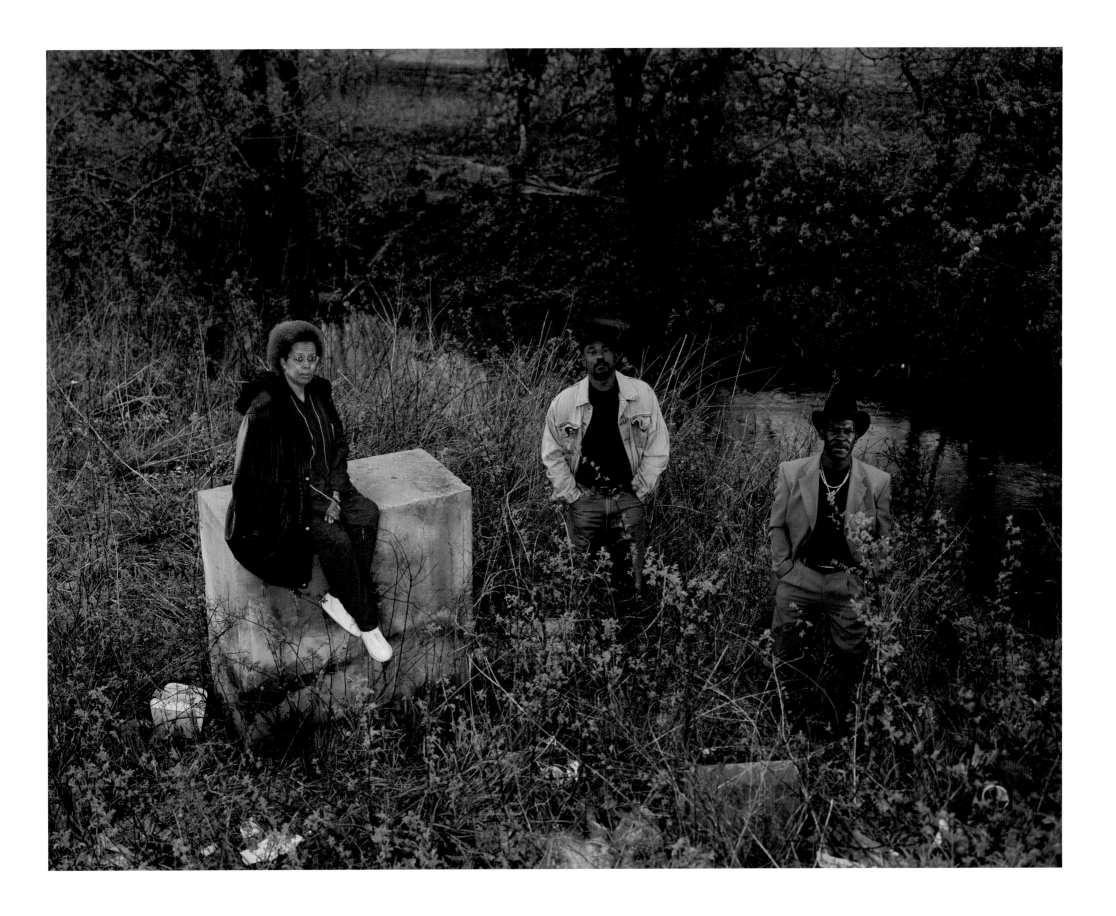

KENNETH WATERS
Scene of the crime, Ayer, Massachusetts
Waters died in an accident 6 months after his exoneration
Served 18 years of a Life sentence

In May 1980, the body of a woman was found in her Ayer, Massachusetts, home.
She had been stabbed more than thirty times and robbed of her jewelry and money.
Police questioned the victim's neighbors, including Kenneth Waters, who told them he
was working at an all-night diner when the crime occurred. Police gathered time cards
from the diner that supported Waters account, but they were later lost. Police also
examined Waters' entire body and didn't find a scratch. The assailant had fought with
the victim and bled profusely at the scene. Two years later, a man dating one of Waters'
ex-girlfriends told police that Waters had confessed to the murder. Two ex-girlfriends
subsequently came forward and testified against him, both claiming that Waters had
made drunken confessions. Waters was convicted of murder and robbery in 1983 and
sentenced to life without parole. For eighteen years his sister, Betty Anne Waters, worked
to prove her brother's innocence. A high-school drop-out and divorced mother of two,
Betty Anne put herself through college and law school in order to work on his case.
In the Middlesex County courthouse, she found blood stains from the crime scene left
by the perpetrator that, by law, could have been destroyed at any time. In 2001, DNA
testing proved that the murderer's blood did not come from Waters. He was exonerated
and released from prison. Tragically, just six months after his release, Kenny Waters died
from head injuries after falling in an accident. A veteran, he received a military burial.

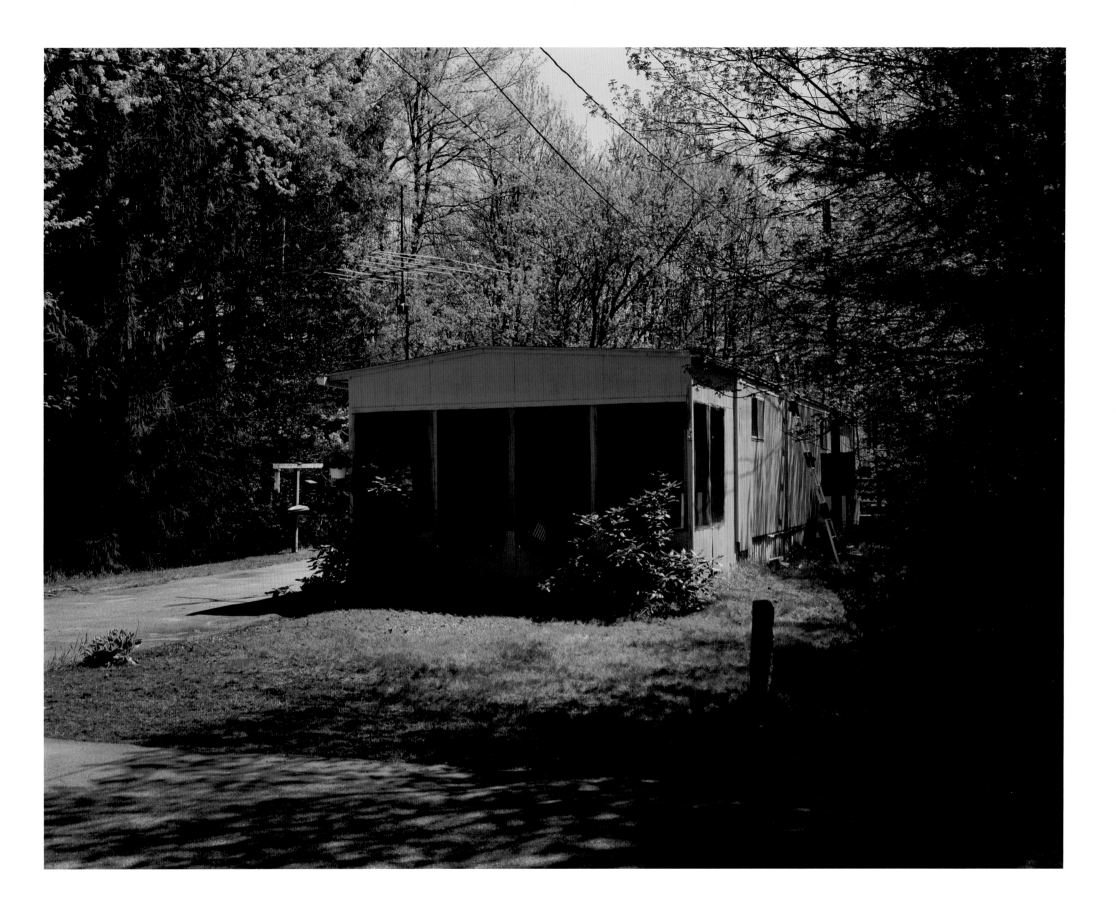

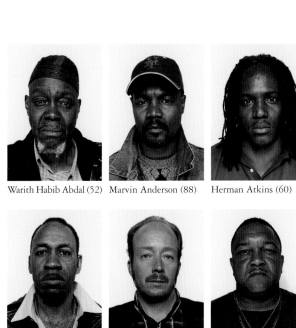 Warith Habib Abdal (52) 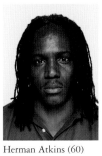 Marvin Anderson (88) Herman Atkins (60) 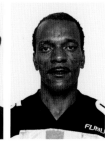 A.B. Butler (20) 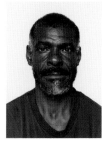 Kevin Byrd (22) 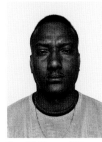 Clyde Charles (34) 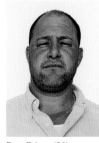 Ronald Cotton (42) Roy Criner (50) 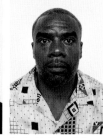 Richard Danziger (38) 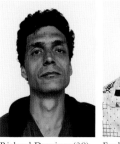 Frederick Daye (10)

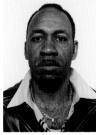 John Dixon (90) 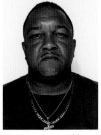 Tim Durham (32) 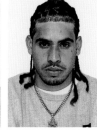 Dougals Echols (64) 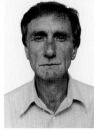 Charles Fain (14) 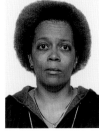 Dennis Fritz (86) 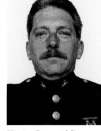 Hector Gonzalez (16) Paula Gray (92) 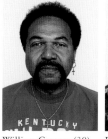 Kevin Green (46) 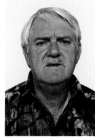 William Gregory (30) Ed Honacker (56)

 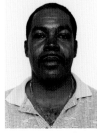 Verneal Jimerson (92) 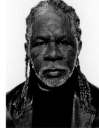 Calvin Johnson (68) 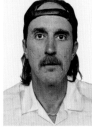 Ronald Jones (48) 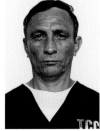 Ray Krone (26) 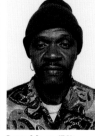 Carlos Lavernia (62) 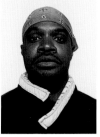 Larry Mayes (70) 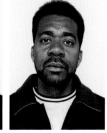 Neil Miller (24) Vincent Moto (58) 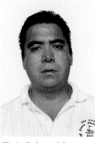 James O'Donnell (80) Chris Ochoa (36)

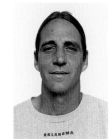 Jeff Pierce (74) 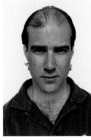 Brian Piszcek (66) 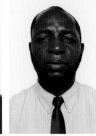 Anthony Robinson (28) 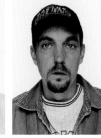 Eric Sarsfield (40) 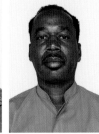 Samuel Scott (64) 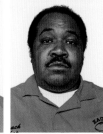 David Shepard (72) 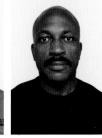 Walter Smith (78) 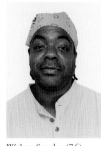 Walter Snyder (76) 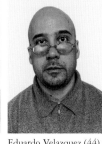 Eduardo Velazquez (44) 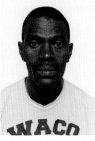 Calvin Washington (54)

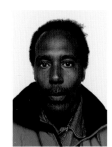 Earl Washington (18) 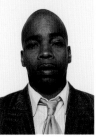 Troy Webb (12) 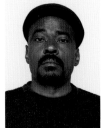 Dennis Williams (92) 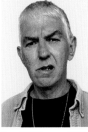 Ron Williamson (84) 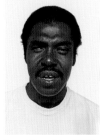 Larry Youngblood (82)

Glossary

Cross-racial Identification: When a suspect—of one race—is positively identified by an eyewitness or victim—of a different race. Research demonstrates that people of one race have increased difficulty in identifying a person of another race; therefore, rates of inaccuracy and misidentification are higher in cases involving cross-racial identification.

DNA (Deoxyribonucleic acid): DNA constitutes the genetic material of all cellular organisms and is made up of nucleotides that form a double-stranded helix. The sequence of those nucleotides determines an organism's genetic code.

DNA Profile: Used as a general term to express the results of DNA testing—the genetic markers obtained from a given sample.

Lineup Procedure: This identification procedure can take several forms. An eyewitness views individuals and is asked if he or she can identify the perpetrator of the crime. In traditional lineup procedure, the witness views all individuals simultaneously. A lineup procedure can also be used for voice identification—a witness is asked to identify a person in a lineup after hearing each subject speak.

Mitochondrial DNA Testing: Mitochondria are cellular bodies, commonly known as the "powerhouse" of the cell, that provide energy for cell functions. They also contain genetic material that is passed down maternally (i.e. DNA shared between mother and child as well as siblings from the same birth mother). In the past, DNA testing was only possible on hairs that still had flesh attached to them (usually the root of the hair) until mitochondrial DNA testing was developed. Because mitochondrial DNA can be found in the shaft of hair, forensic scientists can now test almost any hair collected in an investigation.

PCR-based Testing: Polymerase Chain Reaction. Heralded as one of the most important developments in biological science, PCR "copies" or "amplifies" existing DNA by a method of replication, thus allowing forensic scientists to test samples of minute quantities or samples that have been severely degraded.

Photographic Array: This identification procedure can take many forms. An eyewitness is presented with photographs of individuals and asked if he or she can identify the perpetrator of the crime. In traditional photoarray procedure, the witness views all photographs simultaneously. A photographic array procedure can involve anything from the eyewitness looking through entire books of suspect pictures to examining a small set of photos that are handpicked and presented by investigators.

Rape Kit: Among other services provided, hospitals collect samples from victims for possible use as evidence. Rape kits are tools that standardize this collection process. Rape kits generally include swabs taken from the victim (oral, vaginal, anal, and/or topical), slides produced from the swabs, pubic hair combings, fingernail scrapings, and samples from the victim (blood, hairs). These items are submitted to investigators along with any other applicable physical evidence, like the victim's clothing.

RFLP Testing: Restriction Fragment Length Polymorphism. Employed in the earlier days of forensic DNA testing, RFLP testing requires a large amount of biological material to yield conclusive results, in contrast to newer DNA testing methods.

Serology: Before DNA testing, forensic science was limited to methods like A/B/O blood typing. Often referred to as conventional serology, this general category of forensic testing includes tests to determine the presence of bodily fluids (semen, blood, saliva, etc.), blood typing, and blood group markers. The conclusions drawn from serological testing, in general, are far less probative than the results of DNA testing.

Showup: A one-on-one identification procedure, usually occurring shortly after the crime occurred and near, or at, the actual scene of the crime.

State's Evidence: Evidence for the prosecution. A participant in a crime or an accomplice who gives evidence for the prosecution especially in return for a reduced sentence or other favorable treatment.

STR Testing: Short Tandem Repeat. STR testing is based on PCR methods. STR has been adopted as the standard for the FBI's DNA databank, CODIS (Combined DNA Index System). This system is being used across the world to catalog felons, allowing police agencies to test biological evidence and compare the results to known felon databases.

Resources

ABOUT THE INNOCENCE PROJECT

The Innocence Project at the Benjamin N. Cardozo School of Law is a non-profit legal clinic founded by Barry C. Scheck and Peter J. Neufeld in 1992. The Project works to free the staggering numbers of innocent persons who remain incarcerated, and to bring substantive reform to the system responsible for their unjust imprisonment.

As the Innocence Project celebrates its tenth anniversary, its core mission remains the same: to provide post-conviction legal assistance to persons whose claims of innocence might be demonstrably proven by DNA testing. However, the Project's broader assault on the underlying causes of wrongful convictions has increased in both scope and urgency. In large part due to the Innocence Project's pioneering role and the high-profile exonerations achieved to date, there is a growing demand for its services by prisoners around the nation.

As the criminal justice system comes under more scrutiny, the Innocence Project has been advising and educating lawmakers and advocates on ways to minimize the risk of wrongful convictions. With the help of dedicated law students and volunteers, the Innocence Project's small staff is handling over 200 active cases and screening thousands of additional requests for assistance. With critical assistance from the Innocence Project, twenty-eight states have passed statutes governing the rights of inmates to post-conviction DNA testing and preservation of evidence, and the federal Innocence Protection Act ("IPA") continues to make its way through Congress with broad bi-partisan support. In addition, the Innocence Project works in cooperation with district attorneys and police departments to design and test pilot programs to reform eyewitness identification and to implement other measures that will limit the number of wrongful arrests and convictions. The Project also collaborates with advocates on death penalty moratorium campaigns nationwide.

The Innocence Project helps organize a long-distance learning course for law students across the county, titled *Wrongful Convictions: Causes and Remedies*. Through videoconferencing and web-based communications, fifty schools across the country have participated in the full course, and others have incorporated lectures from the course into their already established clinical programs. On the research front, the Project works with social scientists and others to systematically analyze the factors that led to wrongful convictions. The Project also works with multi-disciplinary groups to design new studies, including a comprehensive analysis of the post-release needs of exonerees, and another analyzing the likelihood that innocent persons have been executed under states' modern-day death penalty laws.

THE INNOCENCE NETWORK

The Innocence Project is but one of many organizations dedicated to freeing the innocent and transforming the criminal justice system. The Center for Wrongful Convictions at Northwestern University in Illinois (whose work is largely credited with leading Gov. George Ryan to declare a death penalty moratorium and, later, to grant clemency to all of the state's death death row inmates) and Centurion Ministries in New Jersey (whose painstaking re-investigations of criminal cases have freed innocent prisoners facing execution or life imprisonment for more than two decades) are among those whose work has achieved international acclaim. There are now more than twenty-five such projects (including two in Australia), with more on the way. The Innocence Network not only vastly expands the Innocence Project's ability to represent clients in individual cases, but also serves as a hub for policy and legislative reform at the state and local level. The website offers a continually updated list of members and information on finding out if there is help near you.

HOW TO HELP FREE THE INNOCENTS

The men in this book were freed through the efforts of The Innocence Project and many other institutions and individuals who have contributed enormously to freeing the innocent. The project relies on financial contributions from individuals, foundations, and corporations to make this work possible. All donations to the Project are fully tax-deductible to the extent provided by law. To make a contribution or learn more about grant opportunities, contact the Innocence Project.

www.innocenceproject.org
55 Fifth Avenue
New York, New York 10003

Acknowledgments

This project would not have been possible without the generous support of many people. Most importantly, the men and women who participated in the photographs and interviews. Without their openess, dedication and trust this book would not exist.

My gratitude to the following individuals is immeasurable:

Sarah Baden
Huy Dao
Louis Gabriel
Kevin Hooeyman
Carol Leflufy
Joseph Logan
Lesley Martin
Raja Sethuraman
Althea Wasow

Special thanks to:

THE JOHN SIMON GUGGENHEIM FOUNDATION

THE INNOCENCE PROJECT
Peter Neufeld
Barry Scheck
Huy Dao
Nina Morrison
Gary Lippman
Jane Siegal-Greene
Vanessa Potkin
Aliza Kaplan

UMBRAGE EDITIONS
Nan Richardson
Lesley Martin
Launa Beuhler

BARON & BARON
Joseph Logan
Fabien Baron
Lisa Atkins
Brian Hetherington
Marion Soulie
Amanda Smith

P.S.1 CONTEMPORARY ART CENTER, A MOMA AFFILIATE
Alanna Heiss
Klaus Biesenbach
Amy Smith Stewart
Antoine Guerrero
Brad Greenwood
Rachael Dorsey

THE NEW YORK TIMES MAGAZINE
Adam Moss
Kathy Ryan
Jodi Quon
Kira Pollack
Sara Rimer

GAGOSIAN GALLERY
Larry Gagosian
Sarah Watson
Tica Wilson

INTERNATIONAL CENTER OF PHOTOGRAPHY
Buzz Hartshorn
Carol Squiers
Brian Wallis

ART & COMMERCE
Carol Leflufy
Jimmy Moffat
Ann Kennedy
Philippe Brutus

ADORAMA
Jacob Dresdner
George Hertz
Irving Lamdau

COLOR EDGE
Raja Sethuraman
John Lee
Peter Giglio
Allan Ng
Chia Chen

And to:
Joel Connaroe
Kathy Ryan

Charlie Rose
Professor James Coleman
Philip Lorca di Corcia
Dr. Michael Baden
Susan Kismaric
Sarah Meister
Kari Mulholland
Richard Schlagman
Bernard & Eileen Wasow
Omar Wasow
Andrew Reuland
Alexis Agathocleous
Danny Barbosa
Bettina Funcke
John Pollack
Alice George
Rob Reynolds
Mary Wigmore
Julia Hasting
Rick Wester
George Pitts
Jason Spingarnkoff
Jeremy Siefer
Frank Morris
Seth Price
Ed Anthony
Lola Gabriel
Jonathan Schmitt
Nico Baumbach
Alicia Brownell
Juman Malouf
Nick Noe
Sam Coleman
Harold Brown
Betsy Pearce
Bruce Paltrow
Blythe Danner
Gwyneth Paltrow
Mary & Carl Alsing
Ruth & Randy Simon
Broadway City Arcade
Dick Simon
Susan Simon
Gillian Simon
Shannon Simon
and especially Jake Paltrow

Thank you to the Innocence Project
and to all the individuals and institutions
that supported this cross-country project:

ALABAMA
Michael Thomas
Meredith Gendron

ARIZONA
Ray Krone
Larry Youngblood
Alice Laitner
Bonnie & Nick Meyer
Carol Wittil, Esq.
Chris Ploard, Esq.

CALIFORNIA
Herman Atkins
Frederick Daye
Castine Daye
Rosie Lee Atkins
Shelly
Dwight Ritter, Esq.

FLORIDA
Richard Danziger
Barbara Oakley and family
Jeff Edwards, Esq.
Jeff Walsh
Bertha Irving

GEORGIA
Douglas Echols
Calvin Johnson
Sam Scott
Calvin Johnson, Sr.

IDAHO
Charles Fain

ILLINOIS
Rolando Cruz
Paula Gray
Verneal Jimerson
Ronald Jones

Dennis Williams
The Center on Wrongful Convictions
Professor Rob Warden
Jennifer Warden and family
Jennifer Linzer
Tom Decker, Esq.
Angela Jimerson
Norma Adams
Jamela Jones

INDIANA
Larry Mayes
Fran Hardy, Esq.
Marsha Mayes

KENTUCKY
William Gregory
Vicki Kidwell

LOUISIANA
Clyde Charles
Lois Charles
Erica Charles

MARYLAND
Kirk Bloodsworth
Brenda Bloodsworth

MASSACHUSETTS
Angel Hernandez
Neil Miller
Marvin Mitchell
Eric Sarsfield
Nona Walker, Esq.
Patricia Ray, Esq.
Denise Sarsfield
Duke Sarsfield
Jess Sarsfield

MICHIGAN
Jeffrey Pierce
Cathy Wahl
Steven Pierce
Kevin Pierce

MISSOURI
Kevin Green
Albert Nichols, Chief Warrant Officer
Skip Rich, Cole County Collector
Command Sgt. Major Nat Gerard

NEW JERSEY
David Shepard
John Dixon

NEW YORK
James O'Donnell
Habib Warith Abdal
Hector Gonzalez
Eleanor Jackson Piel, Esq.
Kim O'Donnell
Little James

NORTH CAROLINA
Terry Chalmers
Ronald Cotton
Jennifer Thompson
Raven Cotton
Richard Rosen, Esq.

OKLAHOMA
Tim Durham
Dennis Fritz
Ron Williamson
Mark Barrett, Esq.
Elizabeth Fritz
Wanda Fritz

OHIO
Anthony Michael Green
Brian Piszczek
Walter Smith
Annie Mandell
Barbara
Bill Gallagher, Esq.

PENNSYLVANIA
Vincent Moto
Andre Moto
Philadelphia Film Commission

RHODE ISLAND
Betty Anne Waters, Esq.

SOUTH CAROLINA
Bruce Godschalk

TEXAS
A.B. Butler
Kevin Byrd
Roy Criner
Carlos Lavernia
Chris Ochoa
Anthony Robinson
Calvin Washington
Jeanette Popp
Sheila Butler
Fred Dannon
Robert Swafford, Esq.
Bill Allison, Esq.
Travis County Correctional Complex
Sheriff Margo Frasier
Major David Balajia

VIRGINIA
Marvin Anderson
Ed Honacker
Walter Snyder
Earl Washington
Troy Webb
Pam Washington
Kaye Mirick
Barry Weinstein, Esq.
Alfred Winston
Edith Snyder
Kate Hill, Centurion Ministries

WEST VIRGINIA
Lonnie Simmons, Esq.

WISCONSIN
John Pray, Esq.

An exhibition organized by P.S.1 Contemporary Art Center will accompany this publication.

Taryn Simon: The Innocents
P.S.1 Contemporary Art Center, a MoMA affiliate, New York

Taryn Simon: The Innocents is organized by P.S.1 Chief Curator Klaus Biesenbach and P.S.1 Exhibition Coordinator Amy Smith Stewart.

The programs at P.S.1 Contemporary Art Center are made possible in part by the New York City Department of Cultural Affairs, the Office of the Borough President of Queens, and the Council of the City of New York.

P.S.1 MoMA

P.S.1 Contemporary Art Center
Museum of Modern Art affiliate
22-25 Jackson Ave at 46th Ave
Long Island City, New York 11101
T: 718 784 2084
F: 718 482 9454
press@ps1.org
www.ps1.org

Biographies

TARYN SIMON

Taryn Simon was born in 1975 in New York. In 1997, she graduated from Brown University. Her photographs have exhibited internationally, and been featured in numerous publications including, *The New York Times Magazine, Vanity Fair,* and *The New Yorker*. In 2001, she was awarded a John Simon Guggenheim Foundation Fellowship in Photography. Her work can be viewed at Gagosian Gallery.

PETER NEUFELD & BARRY C. SCHECK

Peter Neufeld and Barry C. Scheck, co-founded and direct the Innocence Project at the Benjamin N. Cardozo School of Law in New York City. The Project provides *pro bono* representation to inmates throughout the country who claim that DNA testing could prove their innocence. The Project also studies the institutional causes of wrongful convictions and provides remedies to reduce the frequency of future miscarriages of justice. In February 2000, *Actual Innocence: Five Days to Execution, and Other Dispatches From the Wrongly Convicted*, written by Neufeld, Scheck, and Pulitzer Prize-winning *New York Times* reporter Jim Dwyer, was published by Doubleday. Their work has shaped the course of case law across the country and helped establish state and federal legislation setting standards for forensic DNA testing. They both serve as members of the New York State Commission on Forensic Science, a body that regulates all crime laboratories in the state. Neufeld and Scheck have litigated and taught extensively in both the "hard" and behavioral forensic sciences. Much of their work is of public interest, resulting in an enhanced public awareness of national problems, improving the criminal justice system, and legislative reform.

The Innocents

An Umbrage Editions Book

First Edition
English language HC ISBN 1-884167-18-7

For information on the P.S.1 organized exhibition of Taryn Simon's photographs,
contact Amy Smith Stewart, exhibition coordinator at P.S.1: amy@ps1.org
Tel: 718 784 2084 or Gagosian Gallery: Sarah Watson, swatson@gagosian.com
Tel: 310 271 9400 or Natica Wilson, tica@gagosian.com Tel: 212 741 1111

A separate exhibition, organized by Umbrage Editions, of Taryn Simon's headshots
featured on the book cover and interviews with the wrongfully convicted will
tour to education and outreach venues nationally through 2005.

For information and booking details on the educational exhibition,
contact Launa Beuhler, launa@umbragebooks.com Tel: 212 965 0197

The Innocents is published by Umbrage Editions, Inc.
515 Canal Street #4, New York, New York 10013
www.umbragebooks.com
Publisher: Nan Richardson
Managing Editor: Lesley A. Martin
Director of Exhibitions: Launa Beuhler
Assistant Editors: Raya Kuzyk, Emily Baker
Editorial Assistant: Nathan Heiges
Copy Editor: Althea Wasow, Alison Hart
Communications: Anica Archip

Distributed by powerHouse Books
www.powerhousebooks.com

Printed in Verona, Italy by Artegrafica